The Official

FOUR SEASONS
Coloring Book

Universe

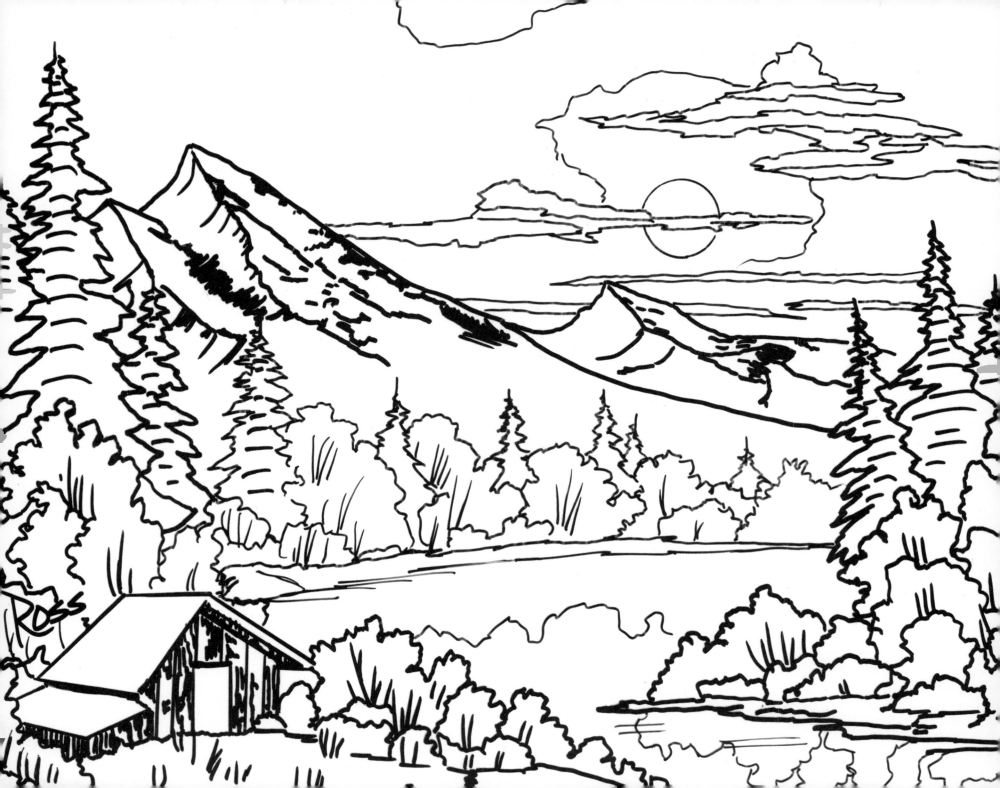

WINTER

"Let's make an almighty mountain.
Everybody likes mountains.
No matter if you live in Florida or Alaska,
mountains are still pretty."

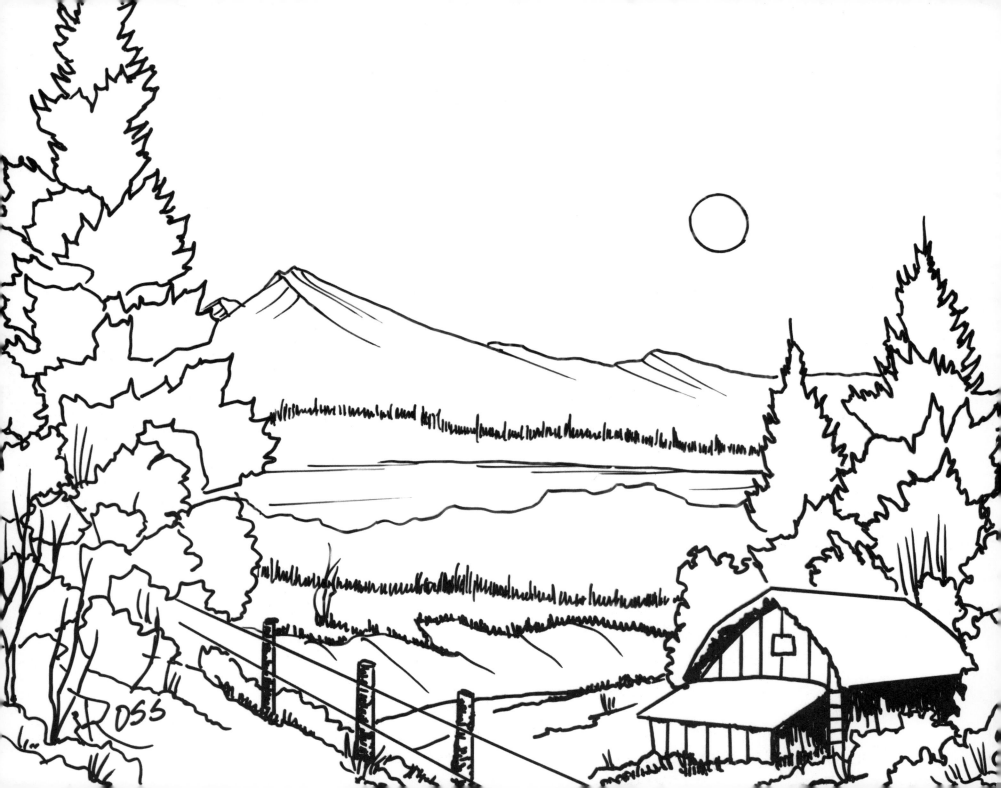

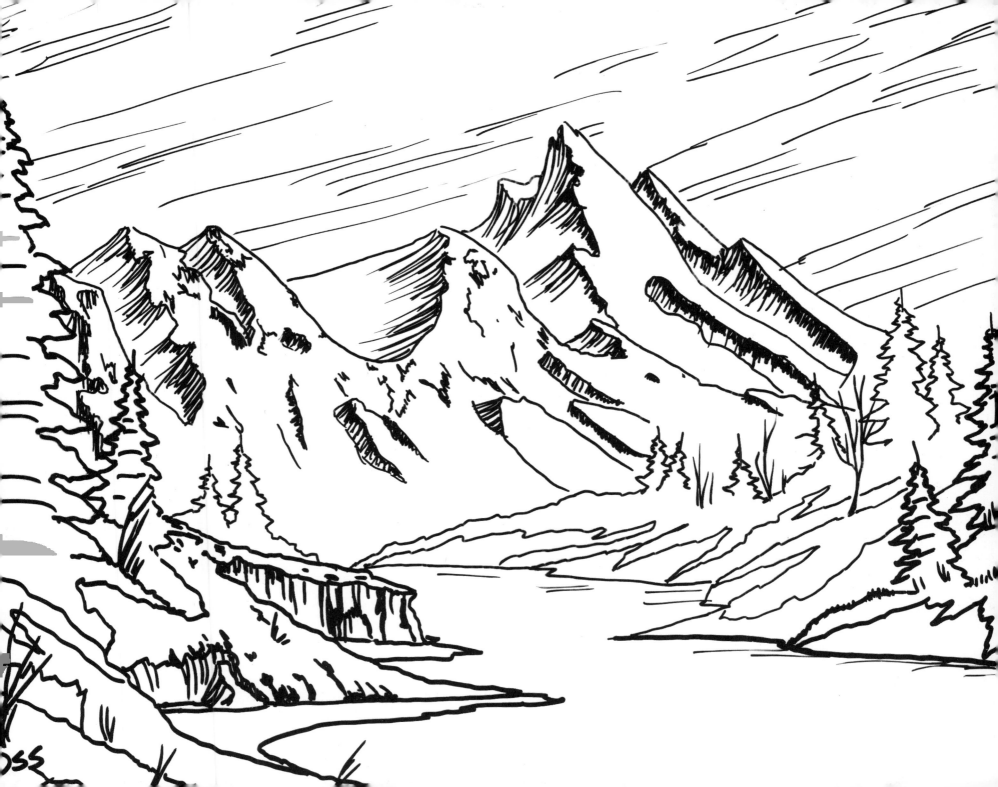

"You can move mountains,
rivers, trees—you can determine
what your world is like."

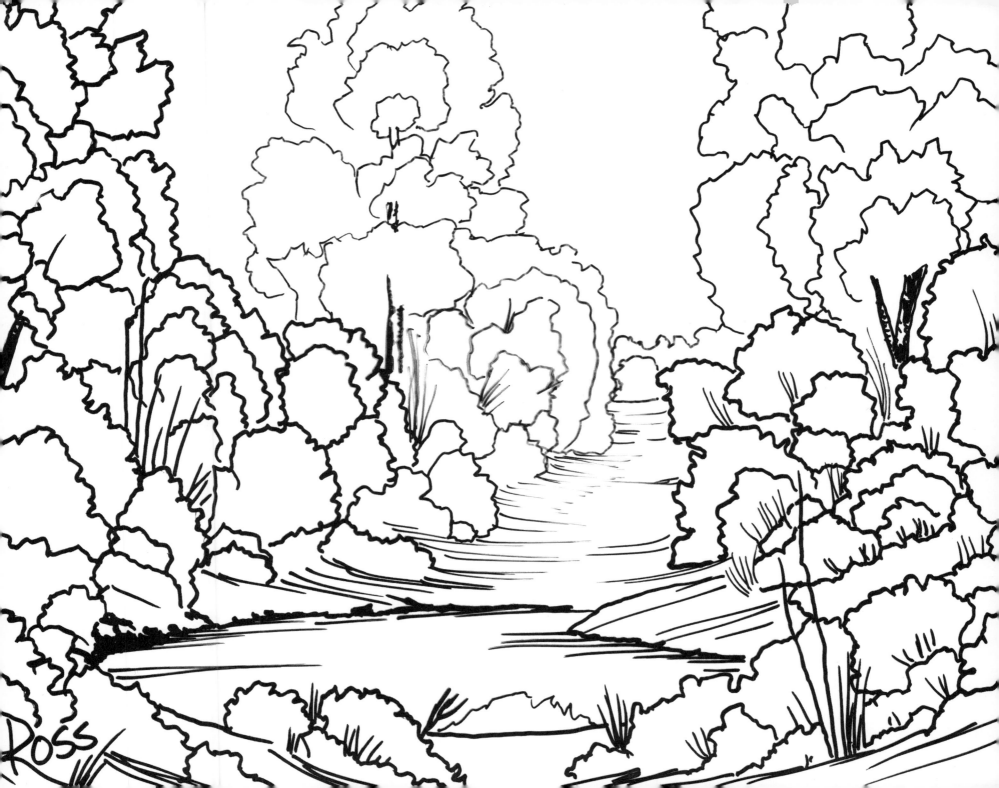

"Let your imagination be your guide.
There are absolutely no limits here."

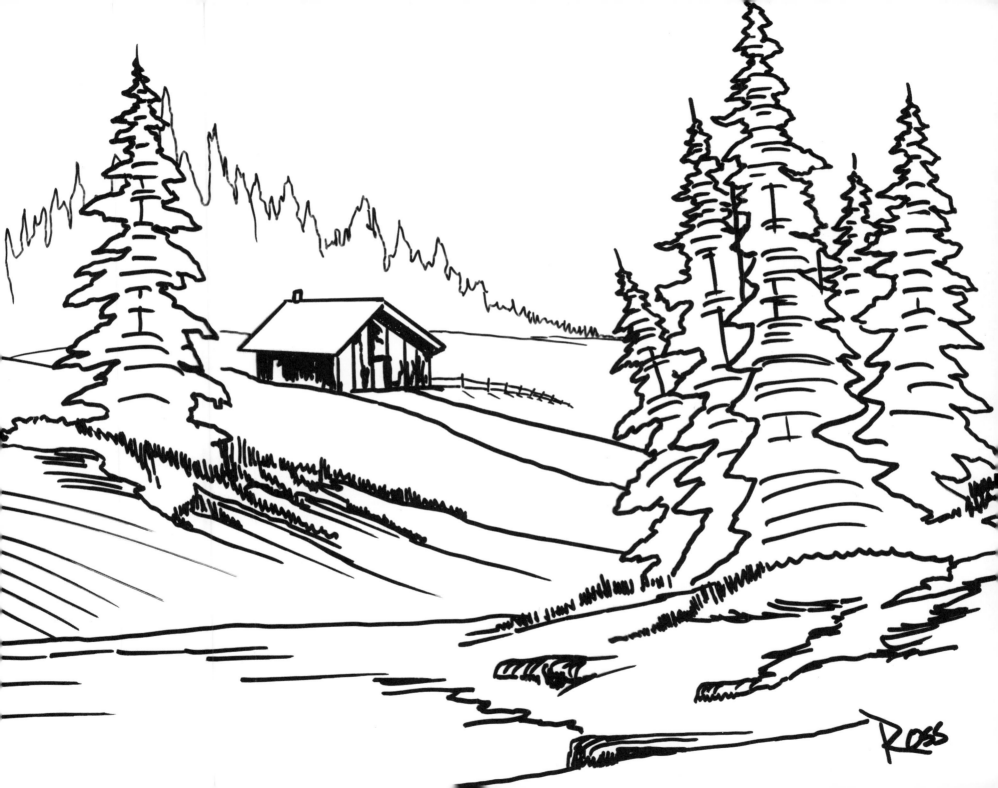

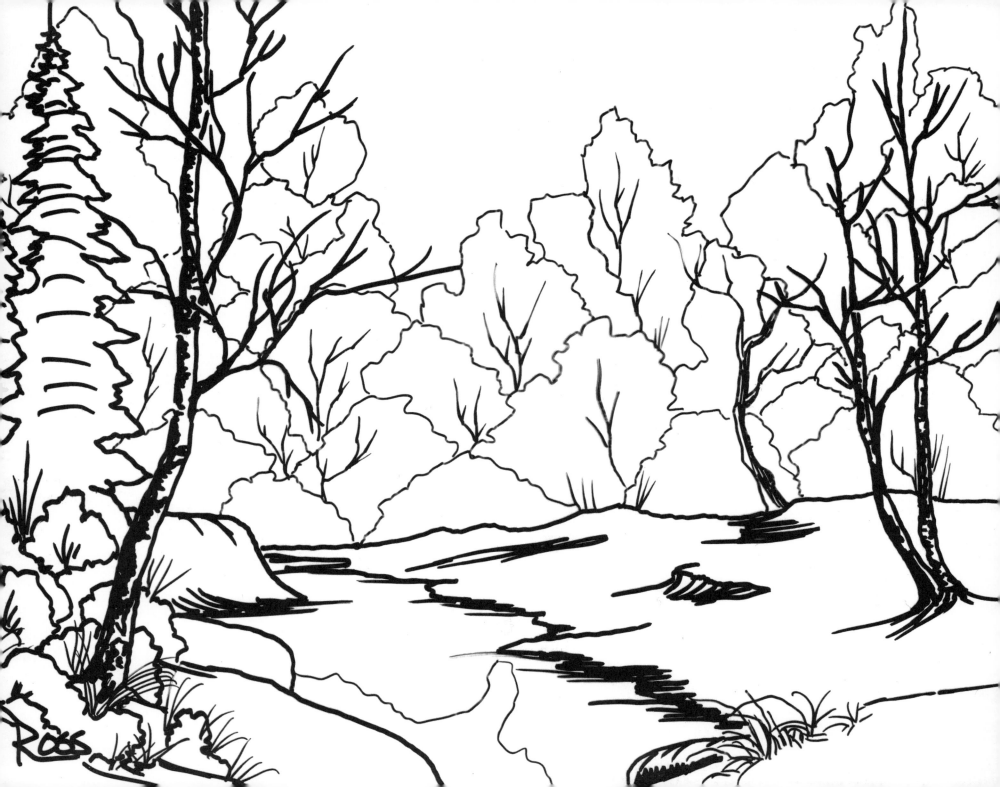

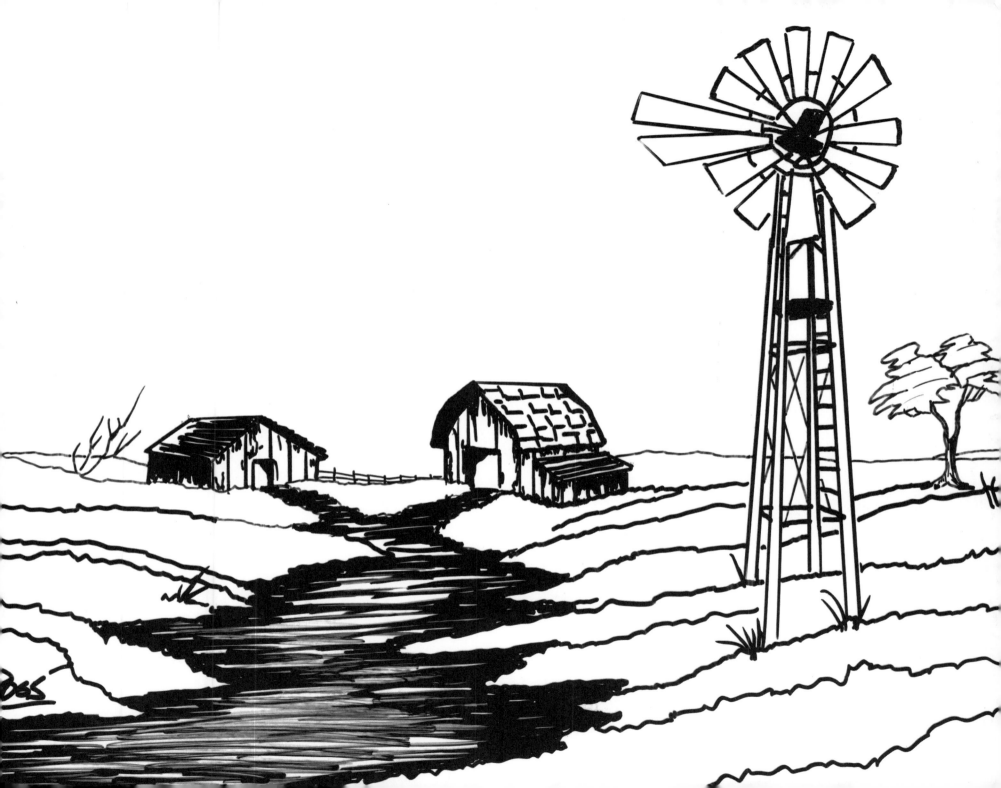

"Anything that you try and don't succeed at, if you learn from it, it's not a failure."

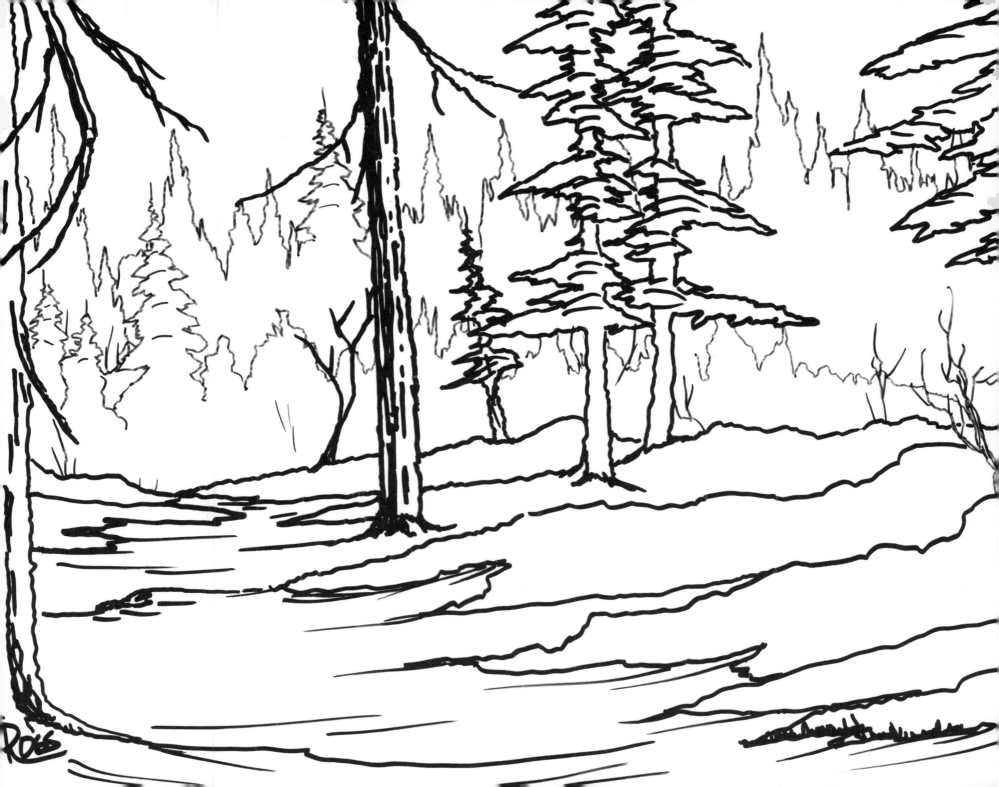

"Let's just dance in a happy little sky today."

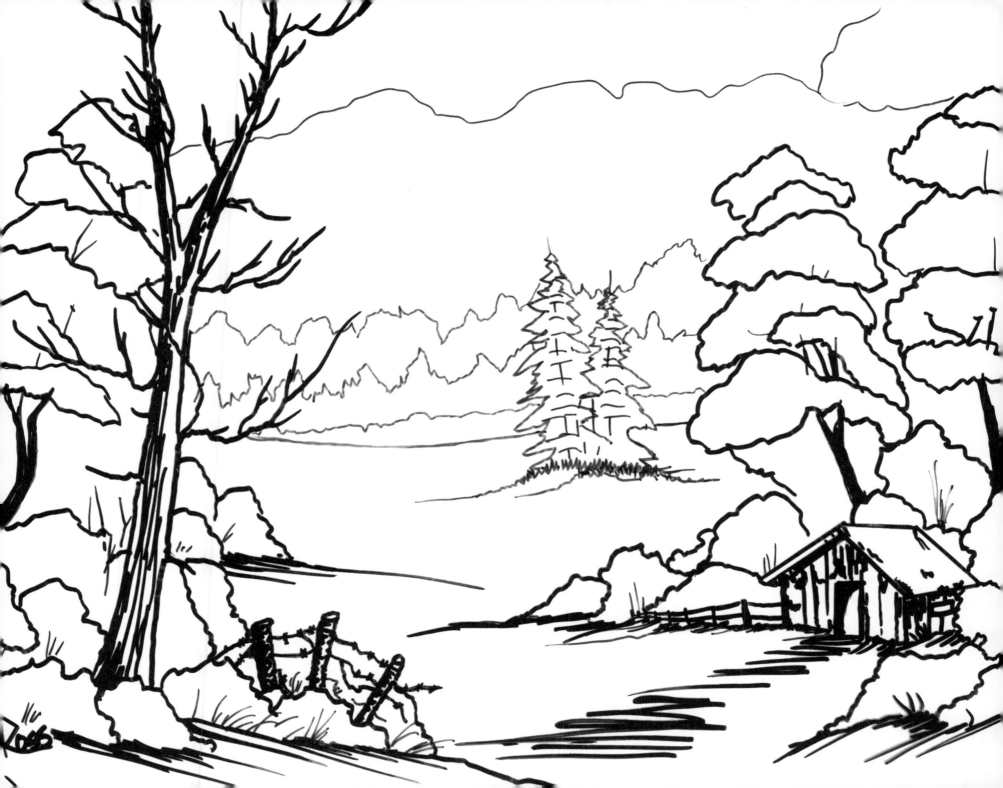

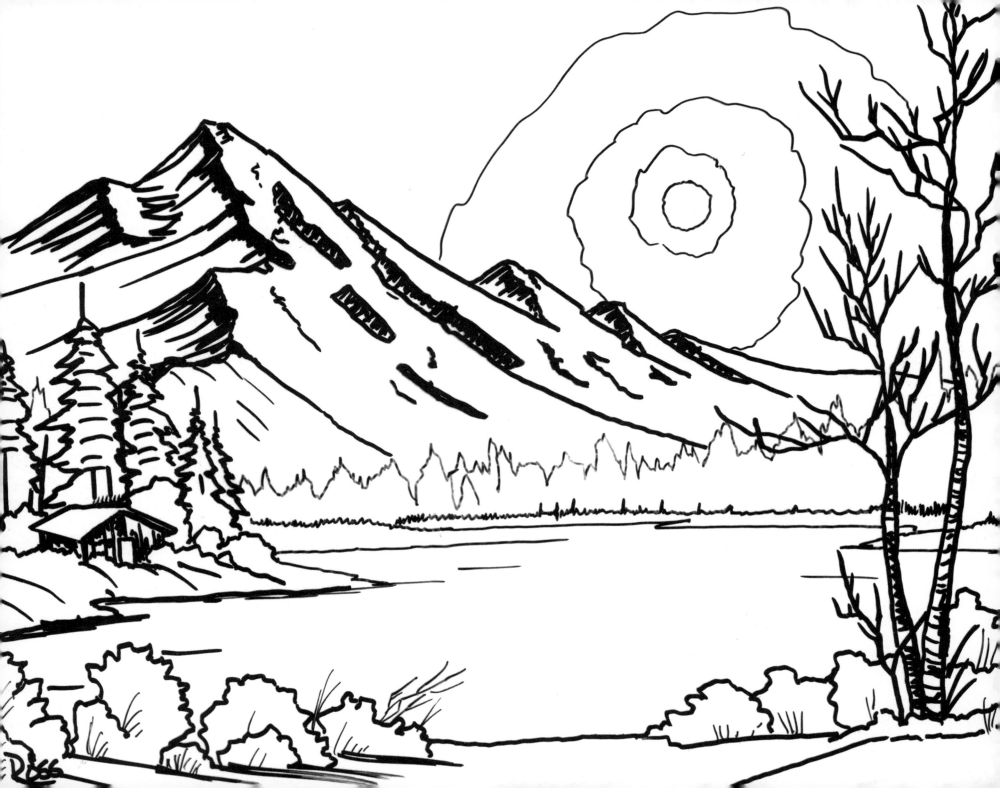

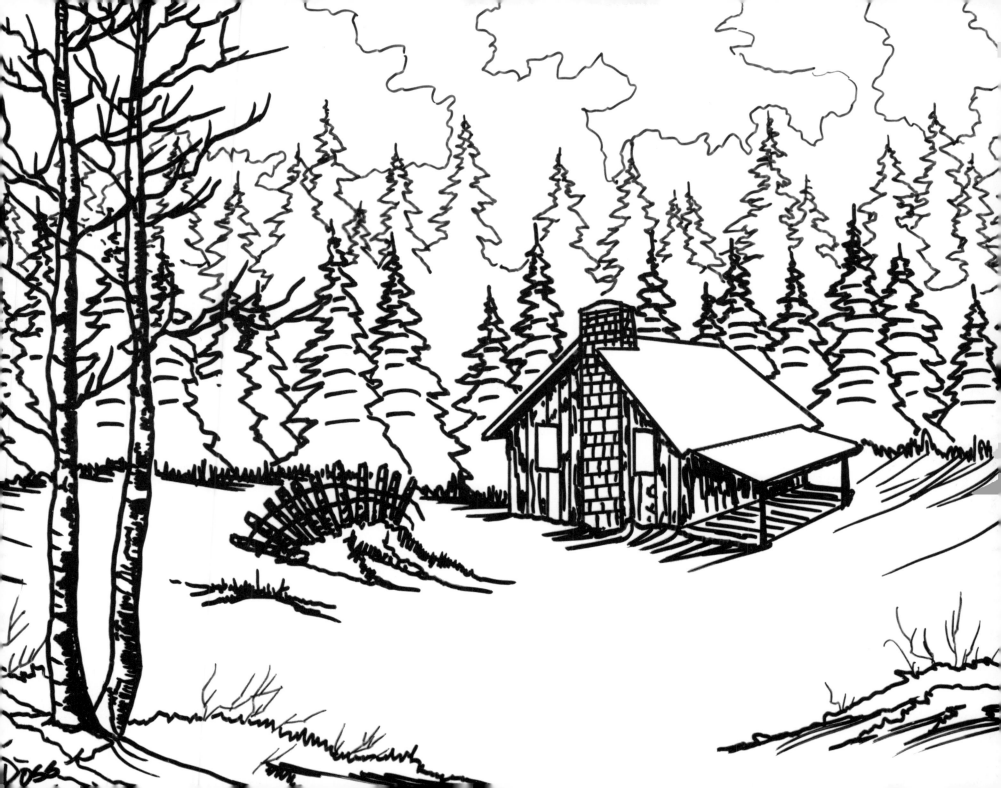

"Things that just happen
are sometimes more beautiful than
things you really sit and plan."

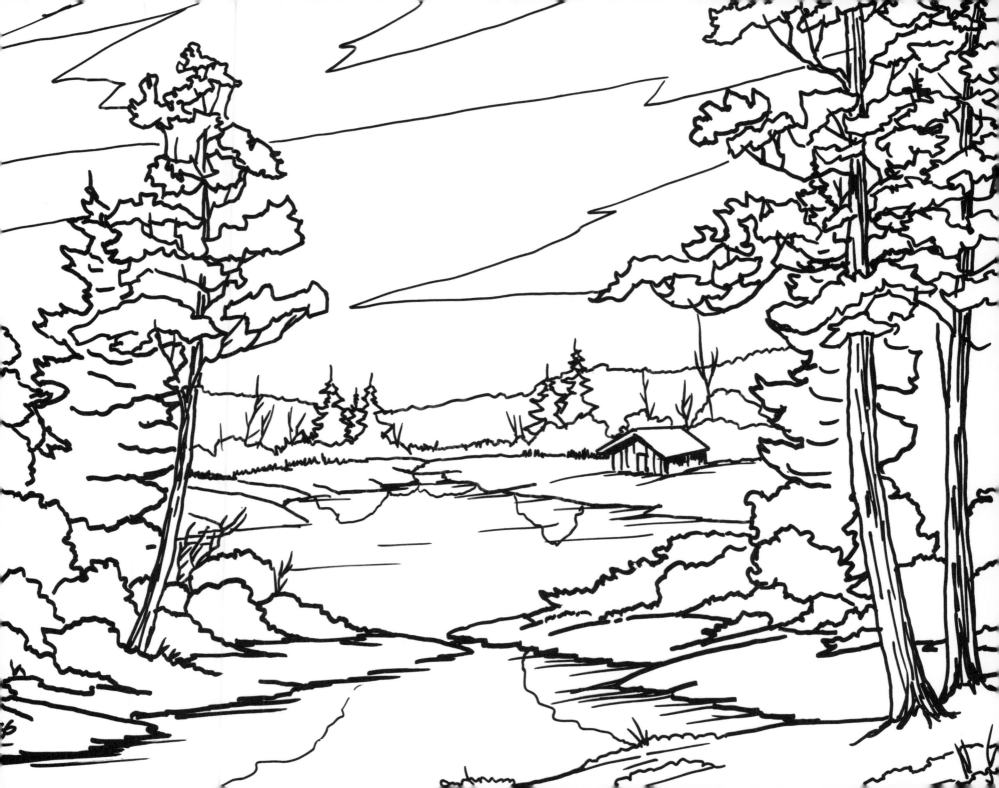

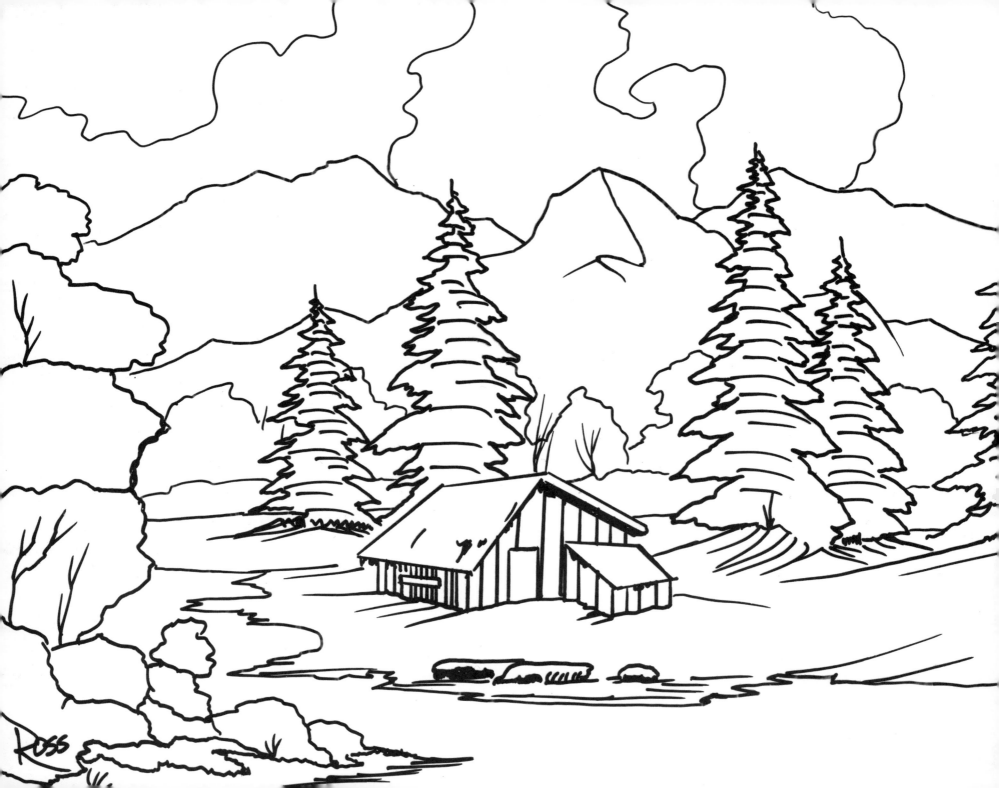

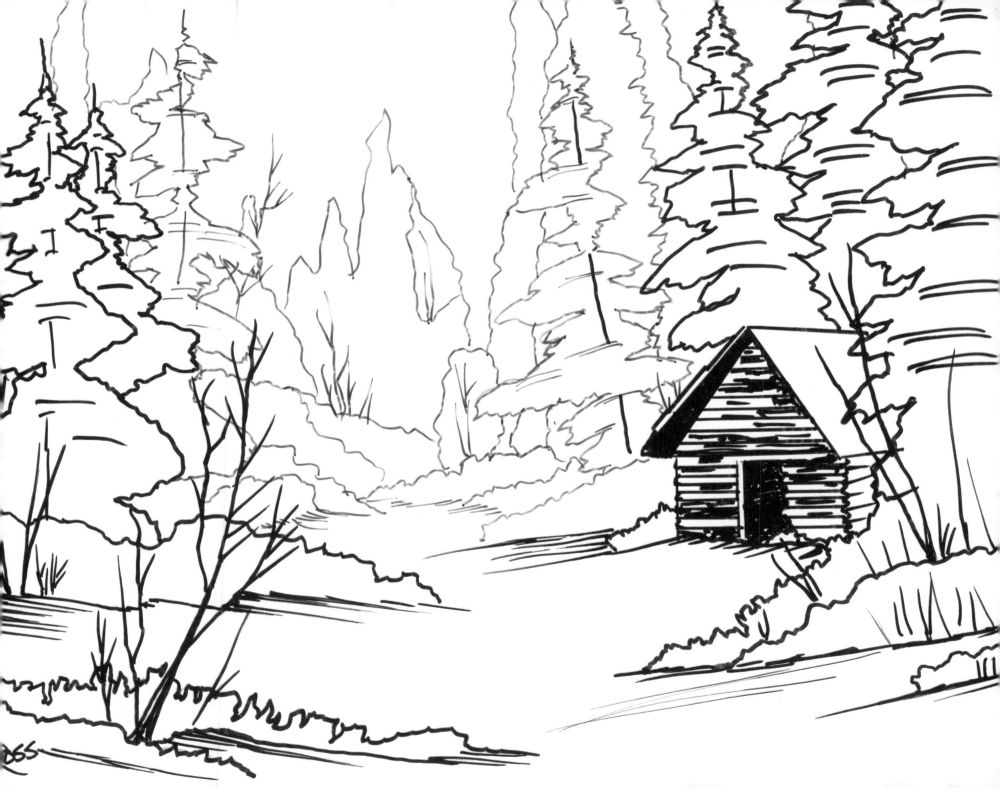

"Success with painting leads
to success with many things, it carries
over into every part of your life."

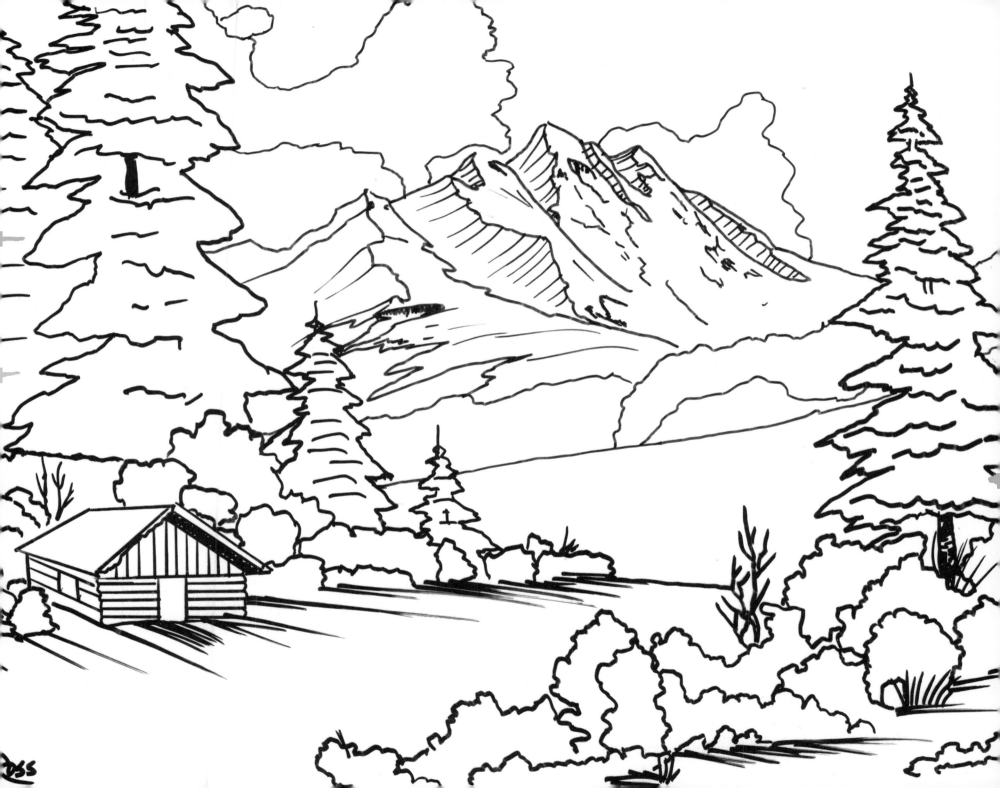

"This is your world right here, and there's no right or wrong. As long as it makes you happy and it doesn't hurt anybody else, then it's fantastic."

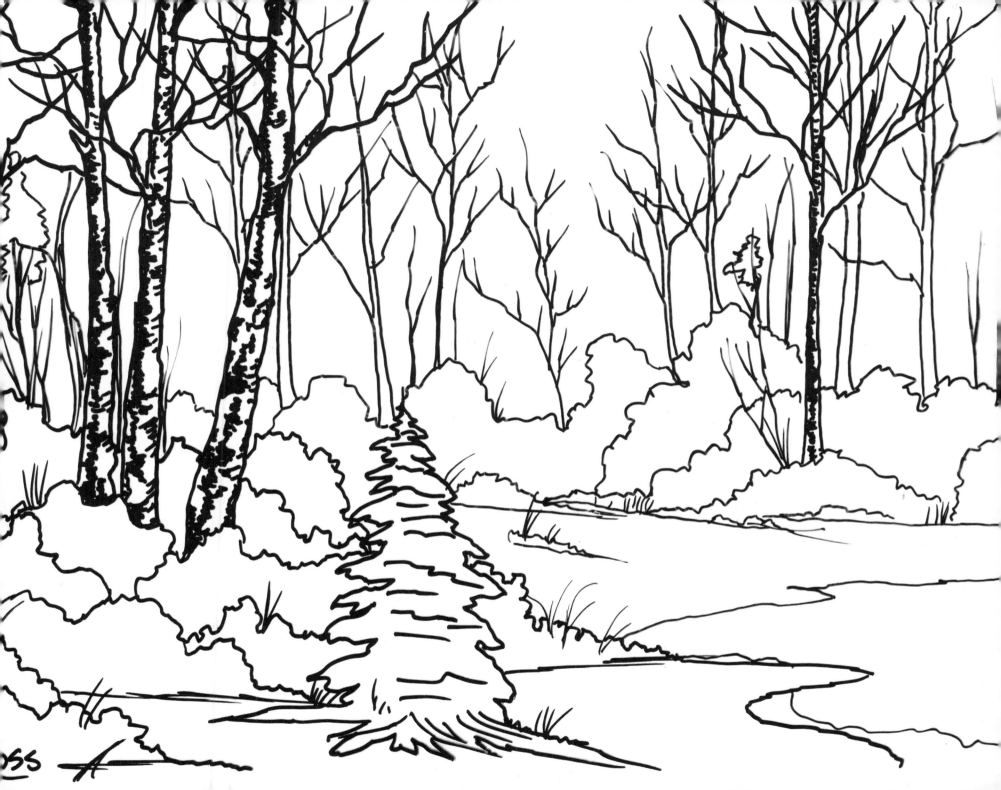

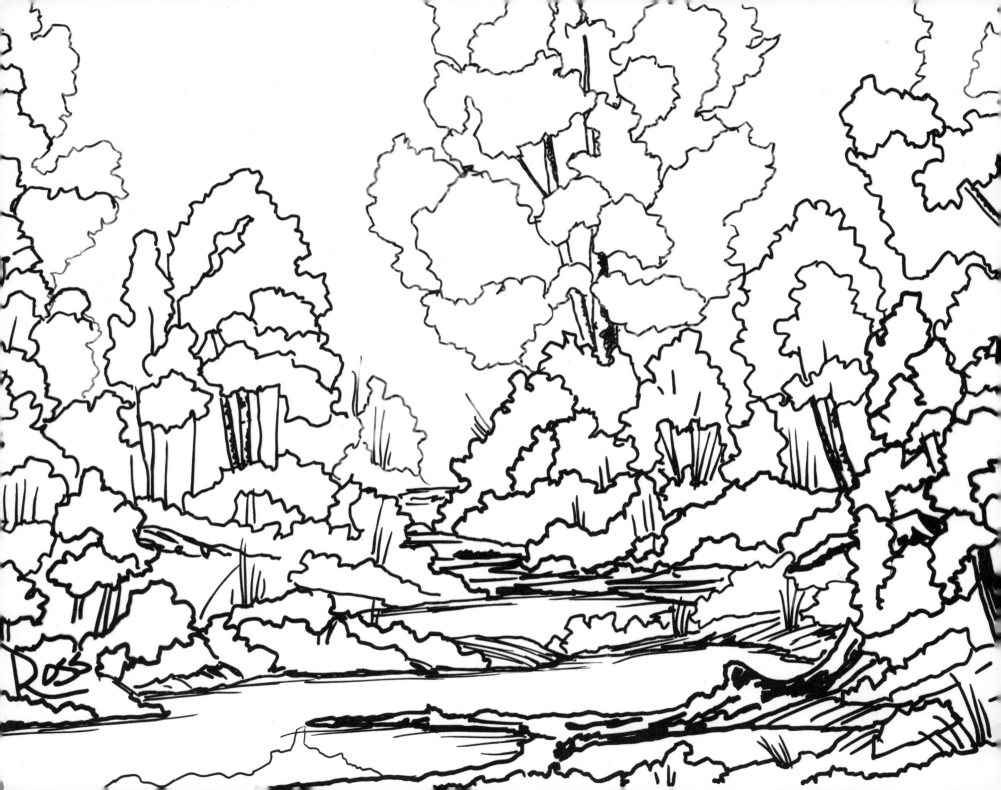

SPRING

"I don't try to understand everything in nature,
I just look at it and enjoy it."

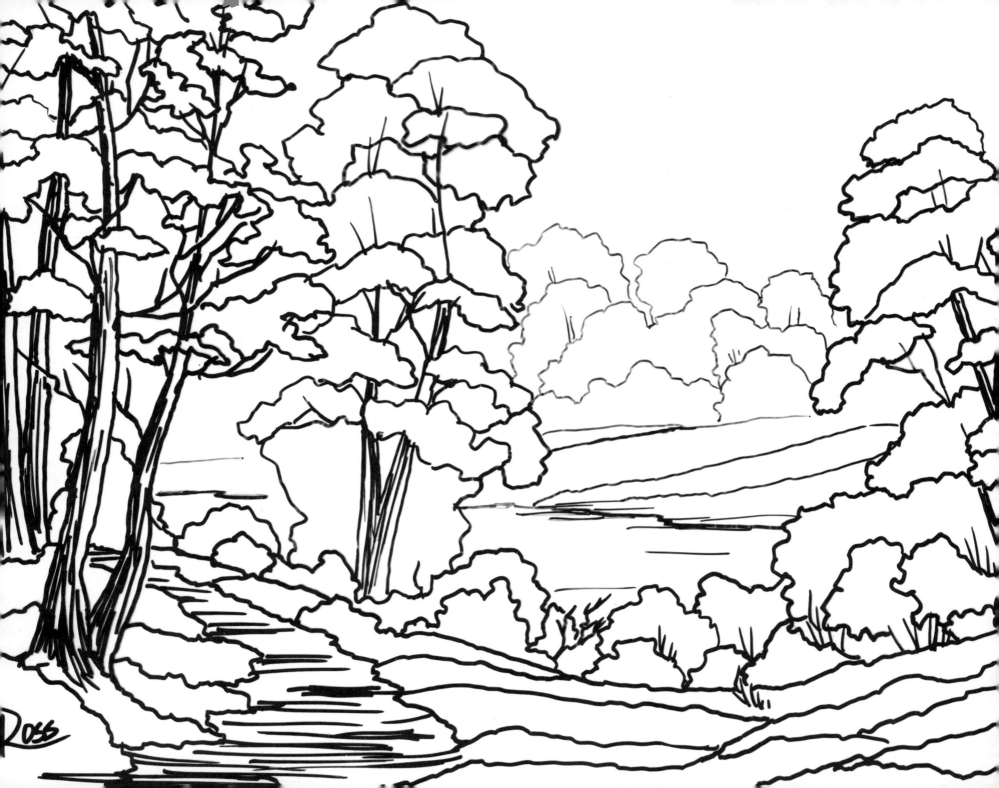

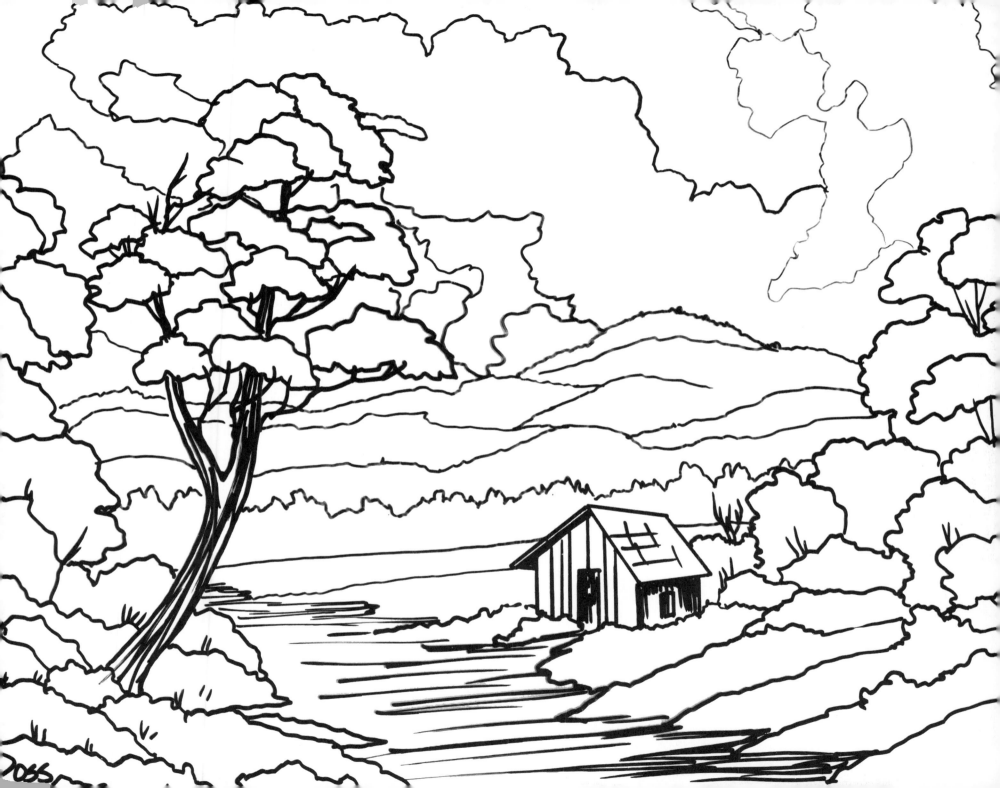

"Today I think we'll do a happy little painting, bright and shiny and pretty, just something that'll make you feel good."

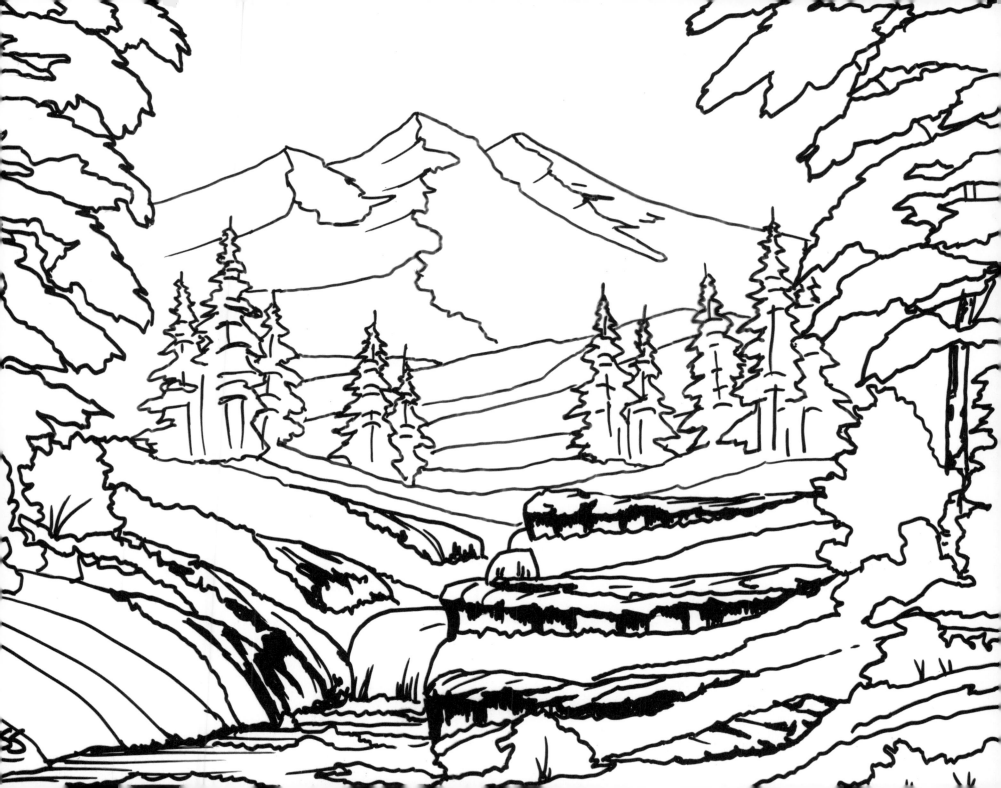

"Spend some time with nature.
Let it become your good friend."

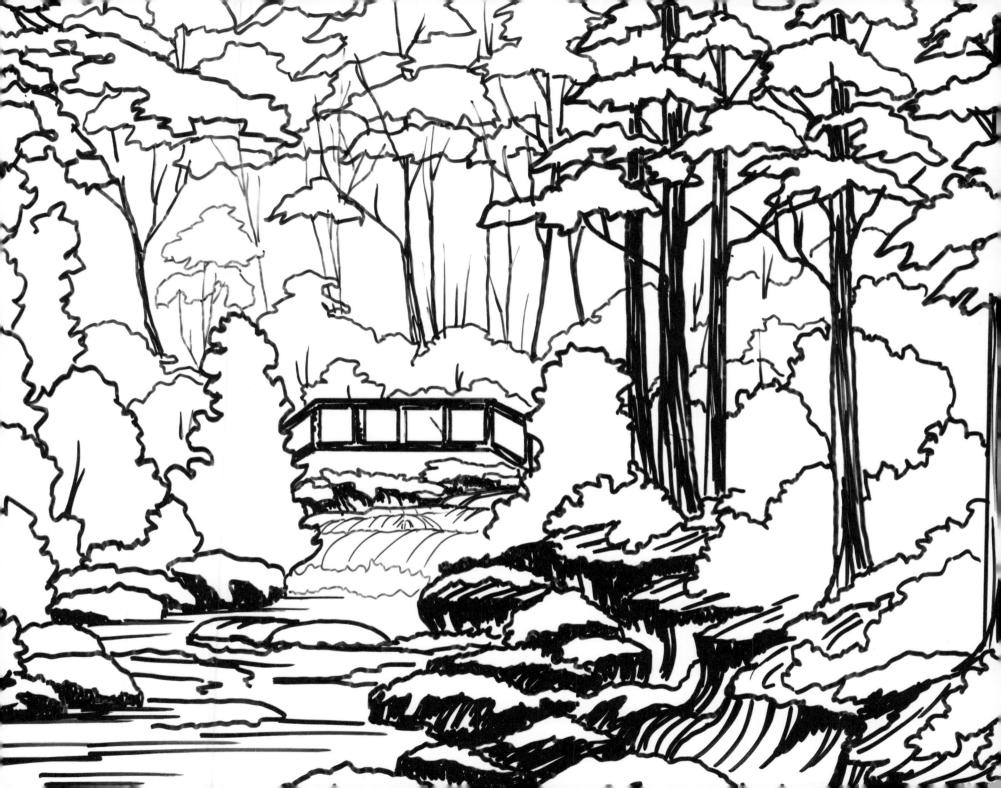

"Anything we don't like, we'll turn
it into a happy little tree or something,
because as you know, we don't make
mistakes, we just have happy accidents."

"Let's put a few little highlights in here to make them little rascals just sparkle in the sun."

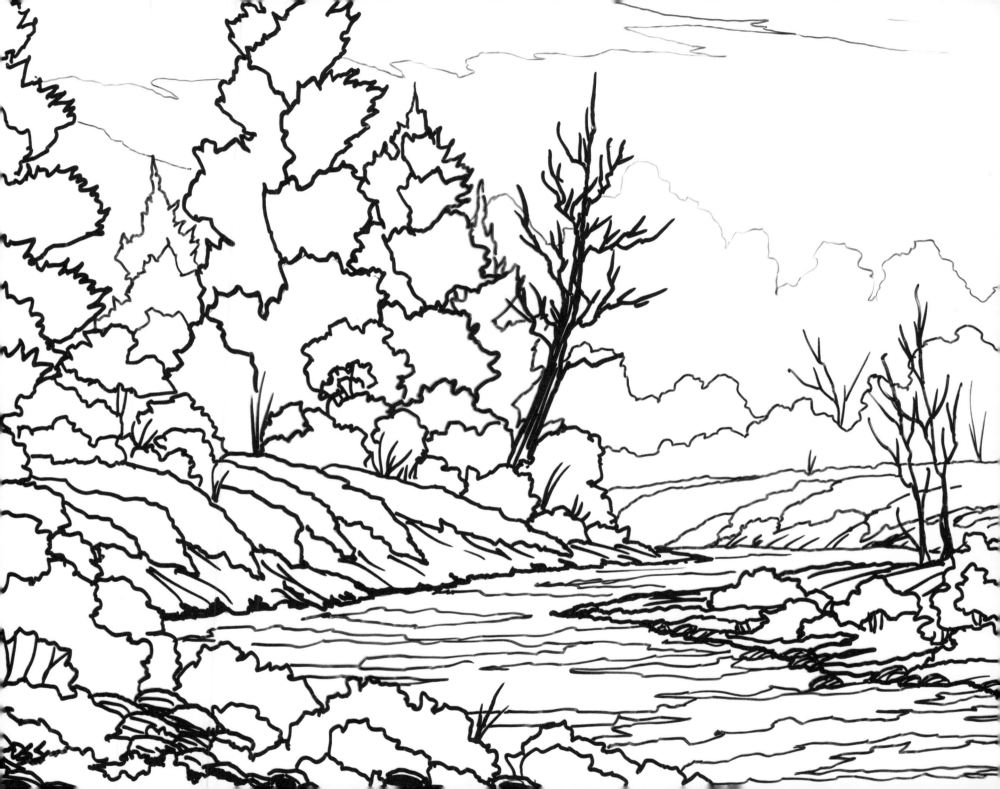

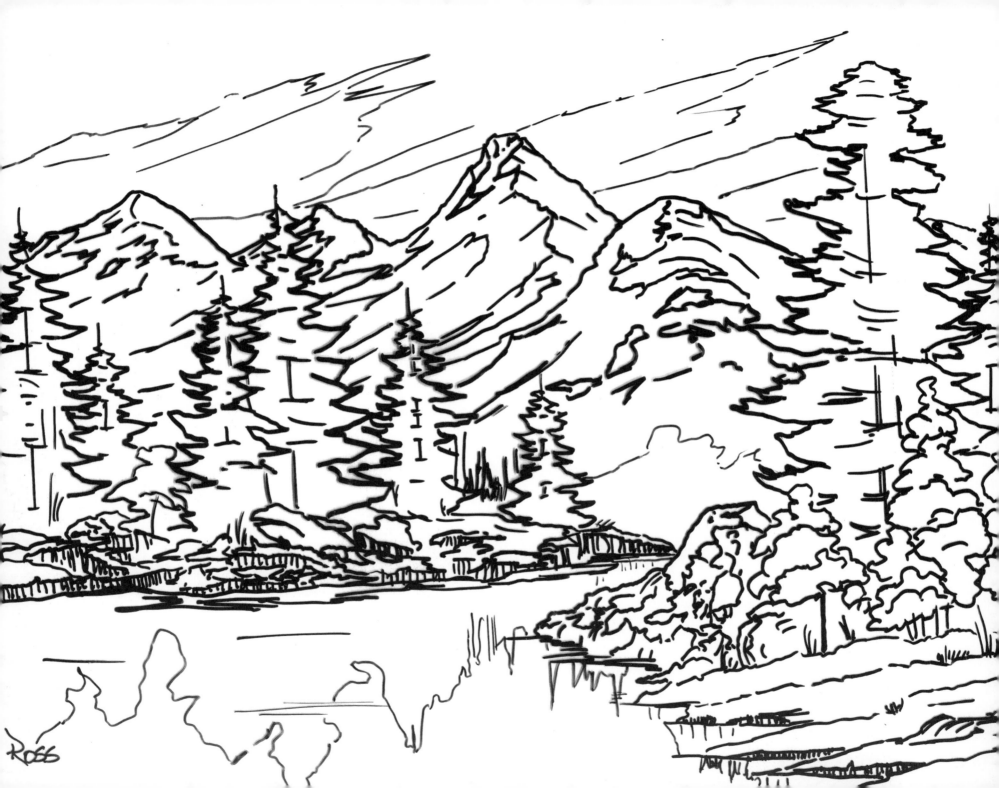

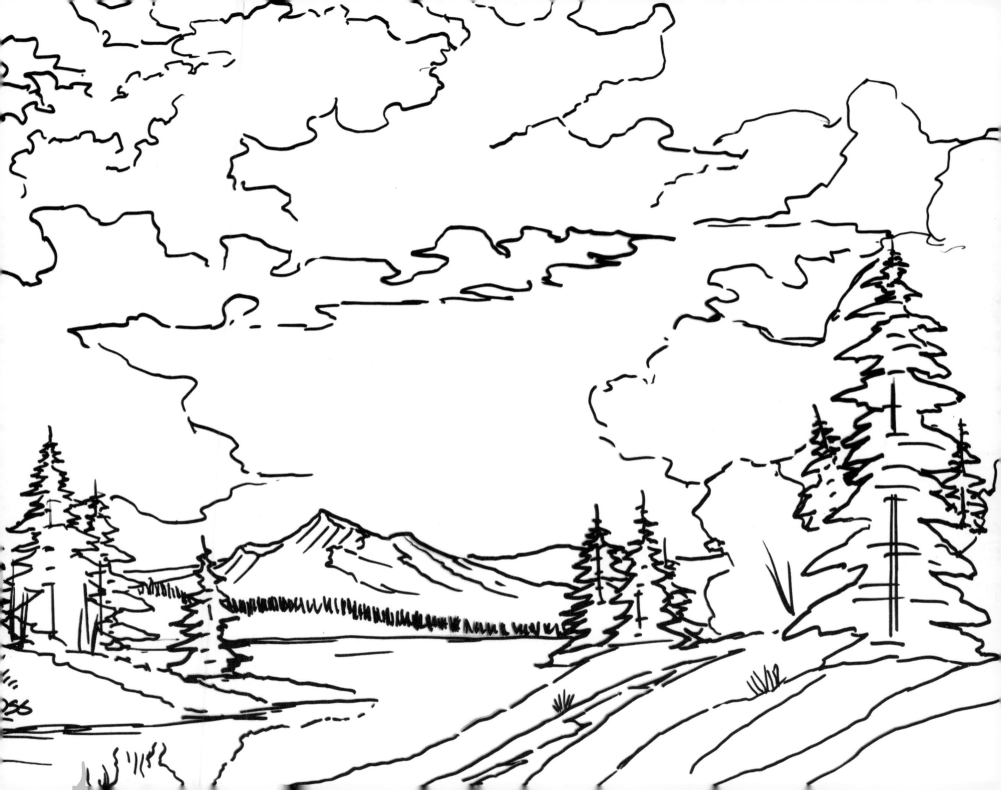

"Just let your imagination go.
You can create all kinds of beautiful effects,
just that easy..."

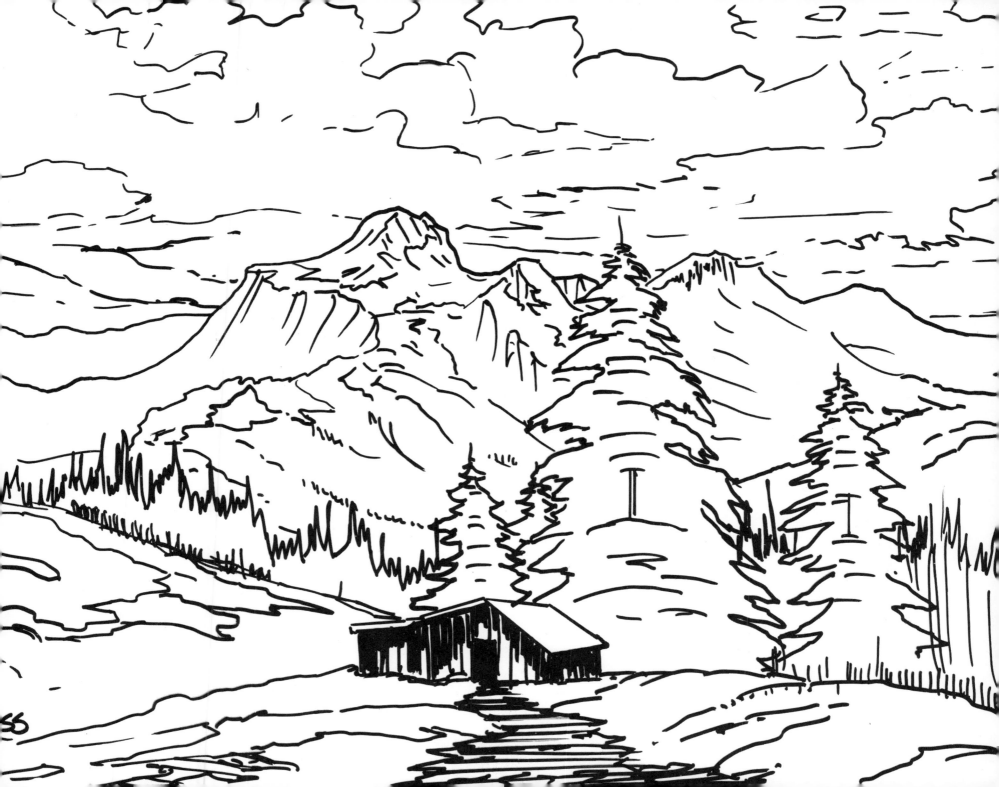

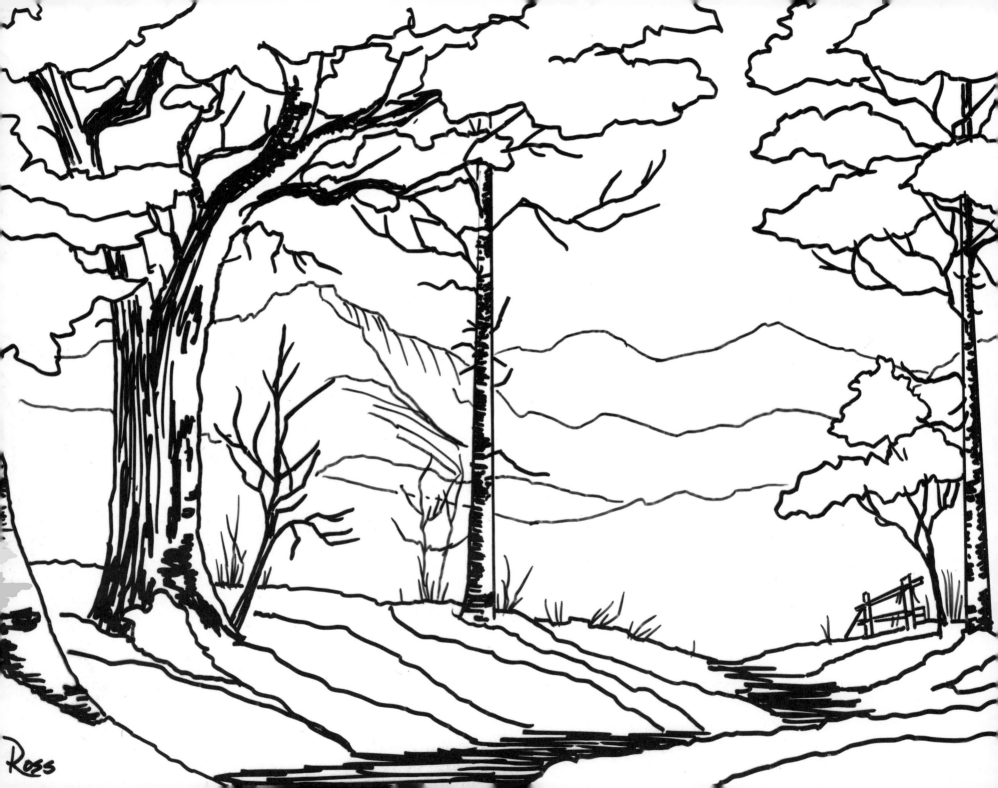

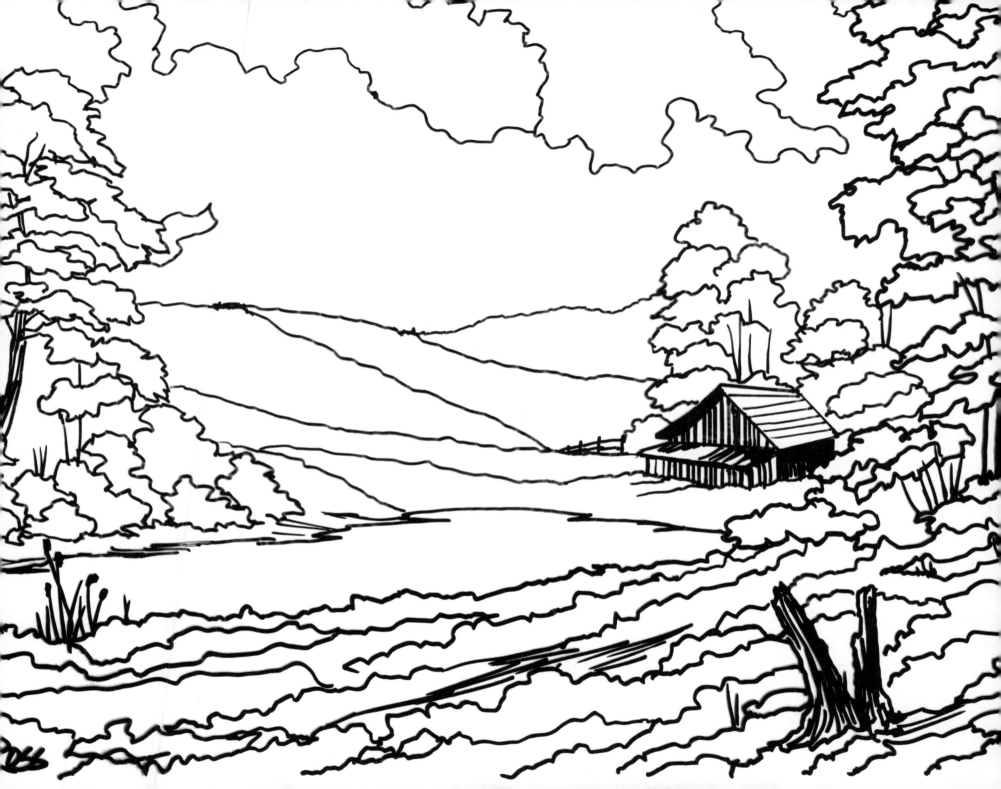

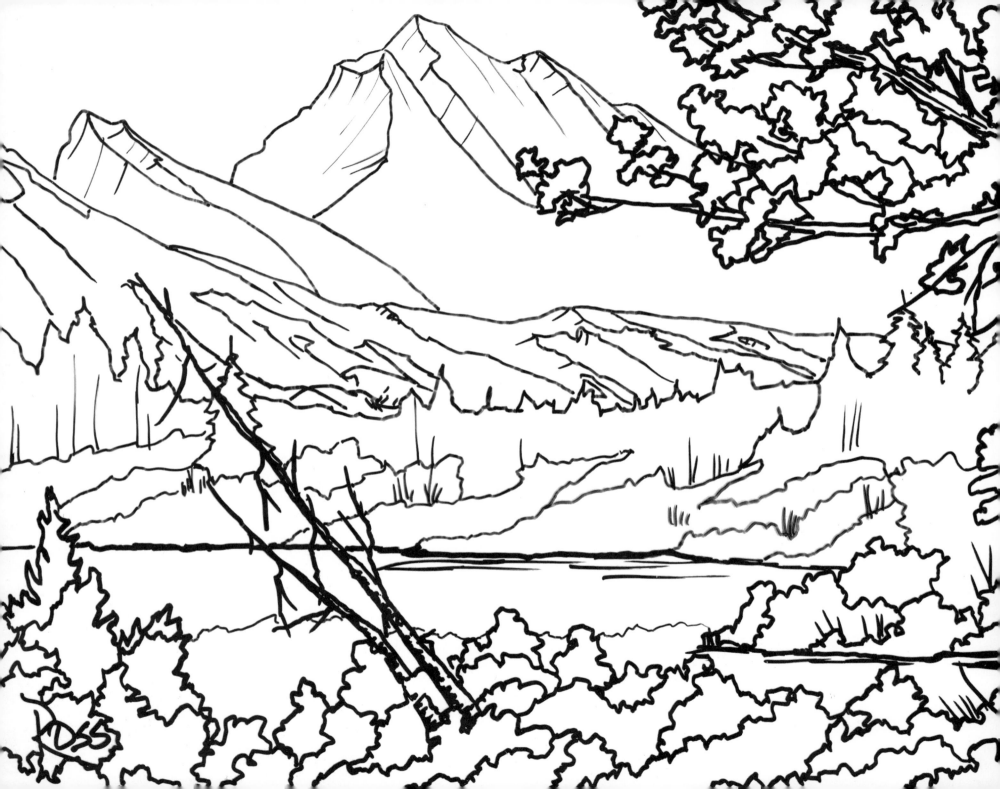

SUMMER

"This would be a good place for
my little squirrel to live."

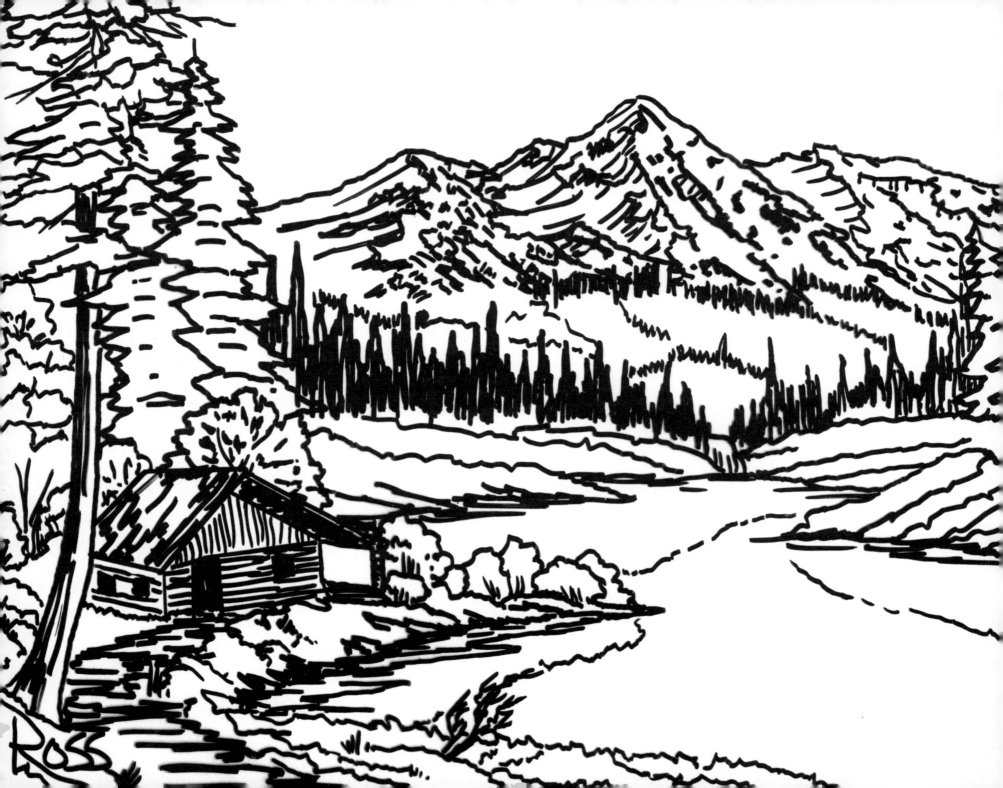

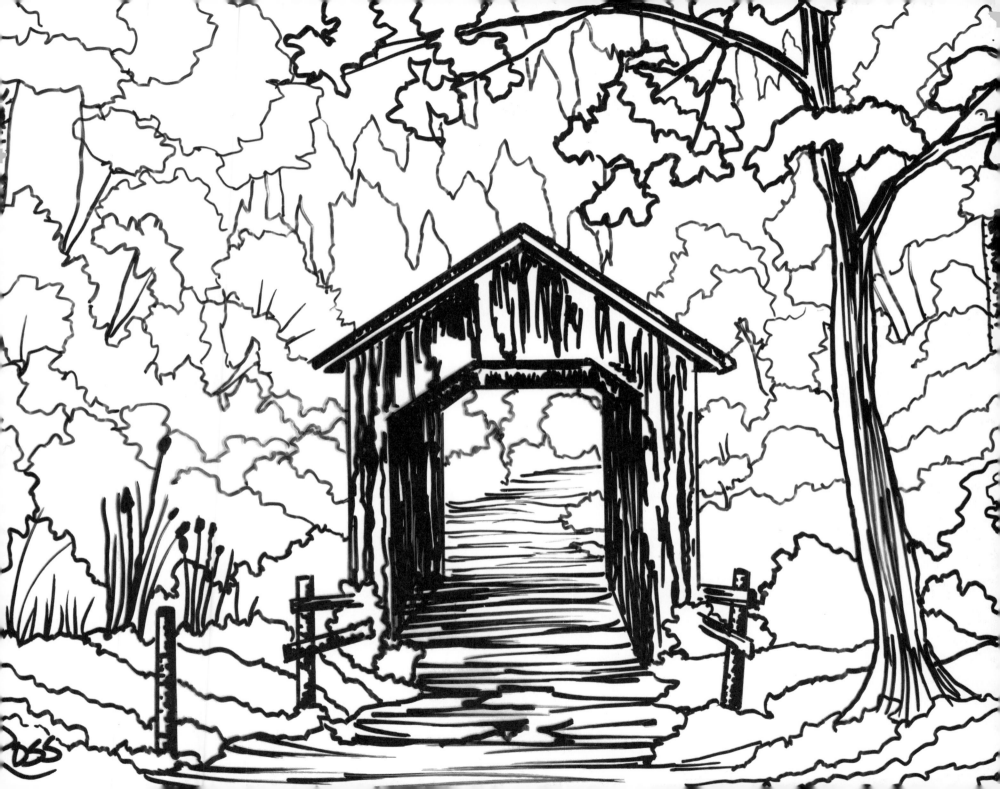

"Just let these big old clouds float
around in the sky and have fun. Clouds
are about the freest thing in nature."

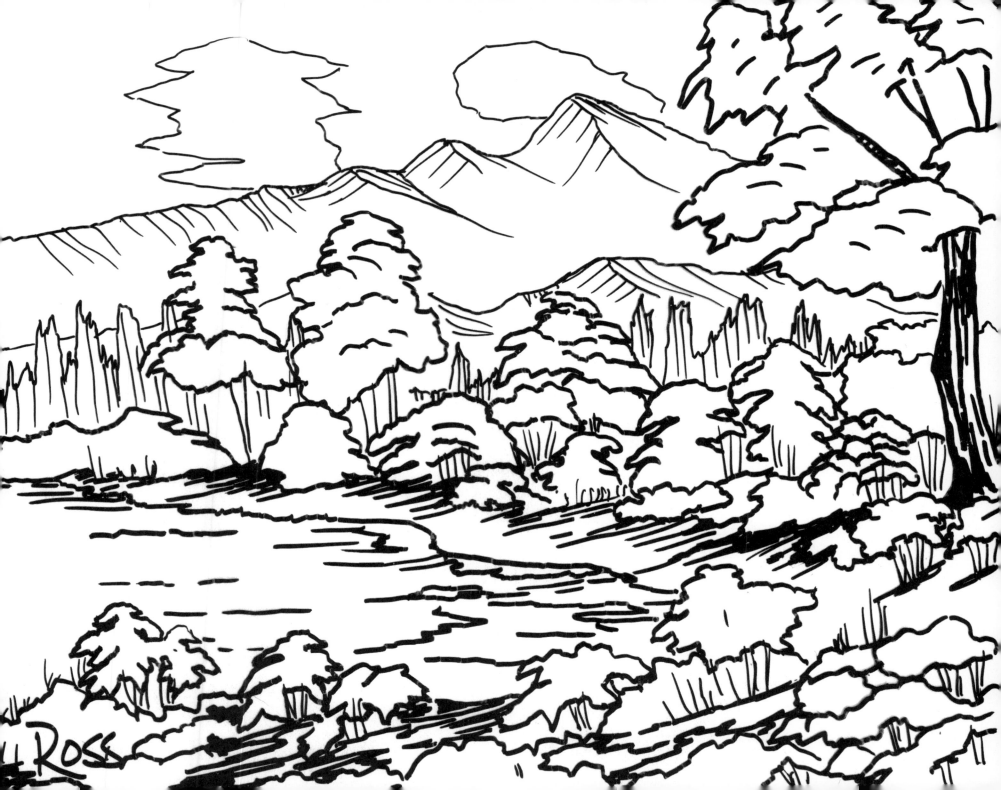

"Anything we don't like, we'll turn it into a happy little tree or something, because as you know, we don't make mistakes, we just have happy accidents."

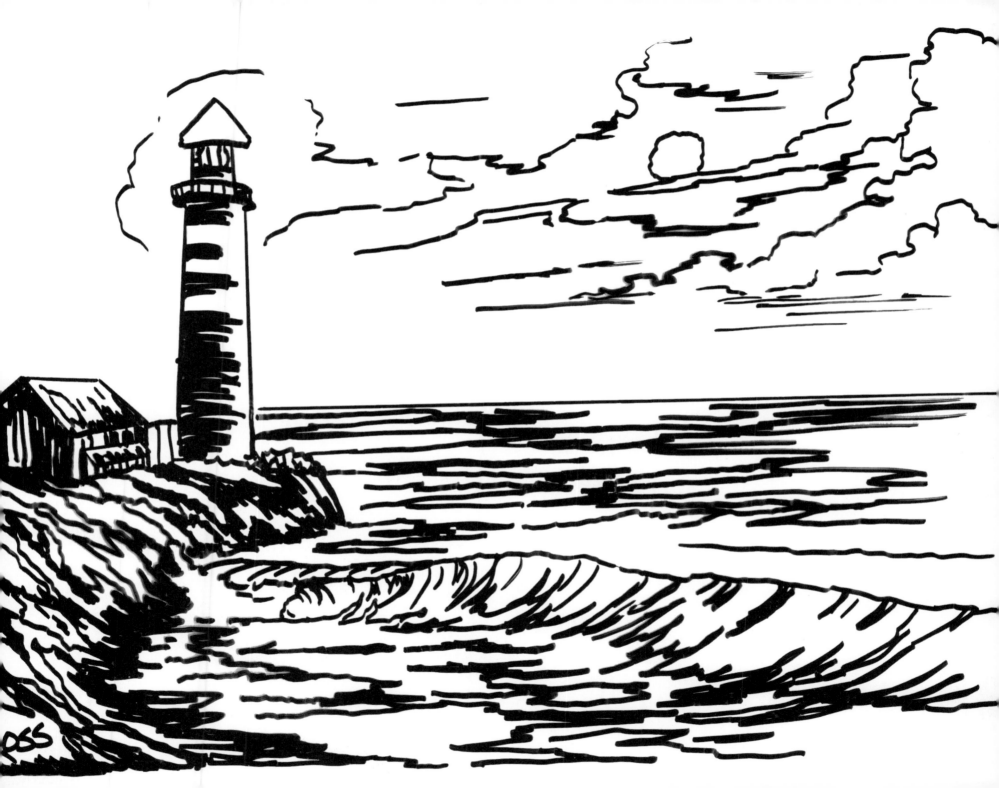

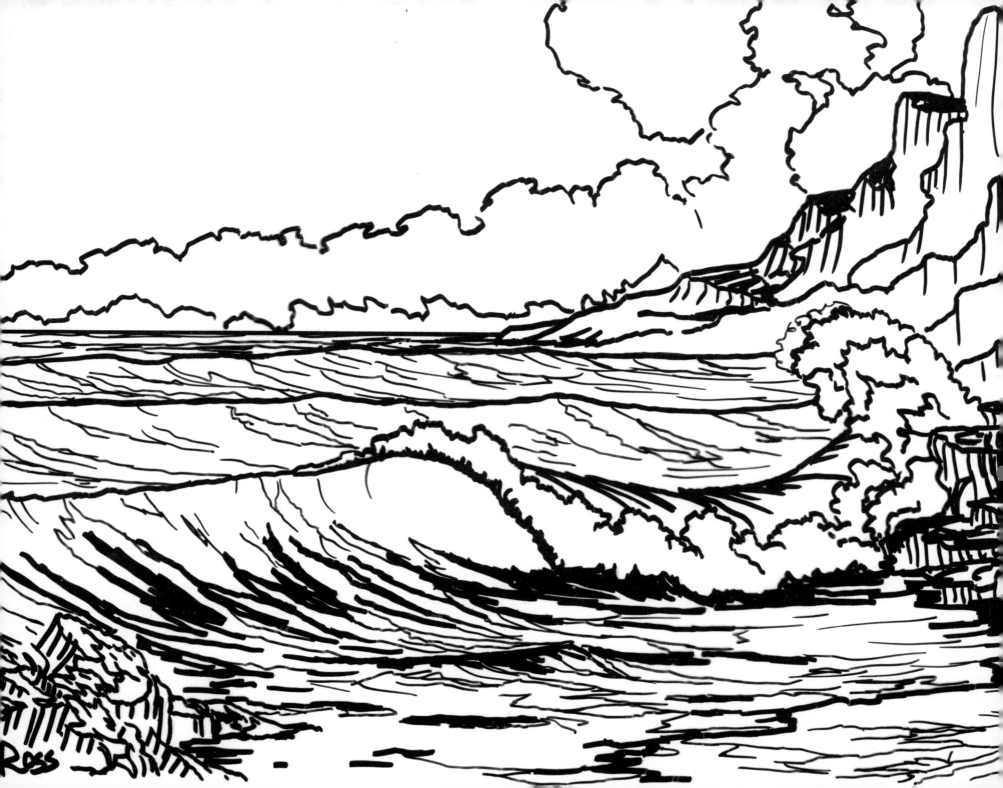

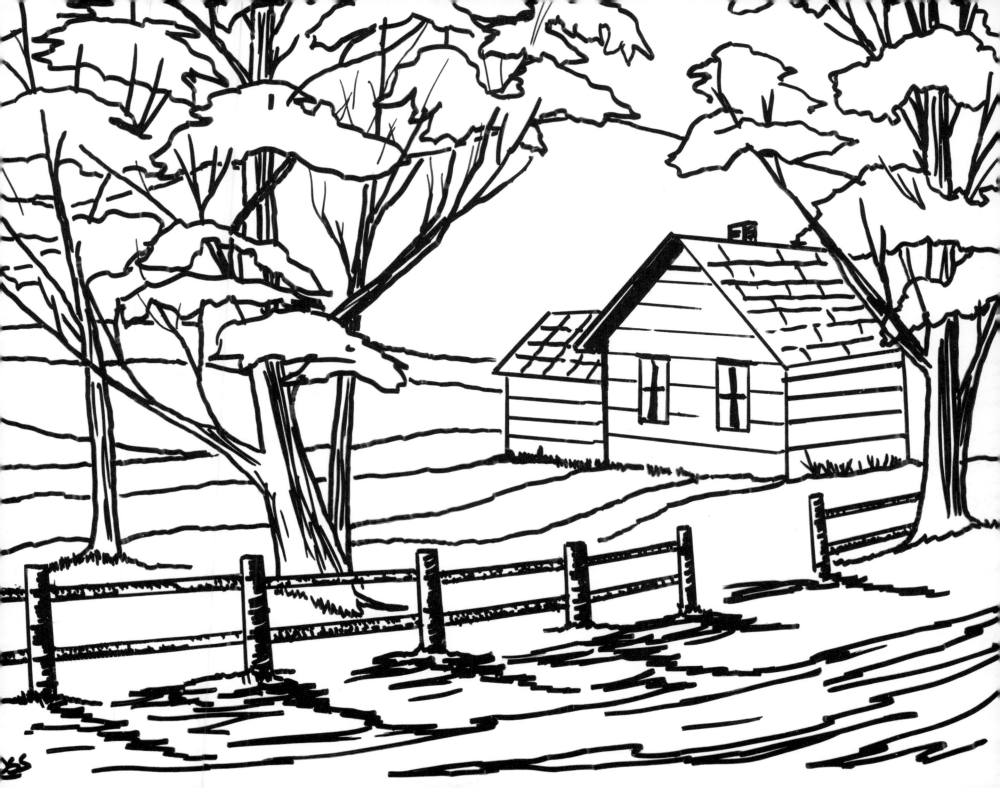

"This is not something you should labor over or worry about."

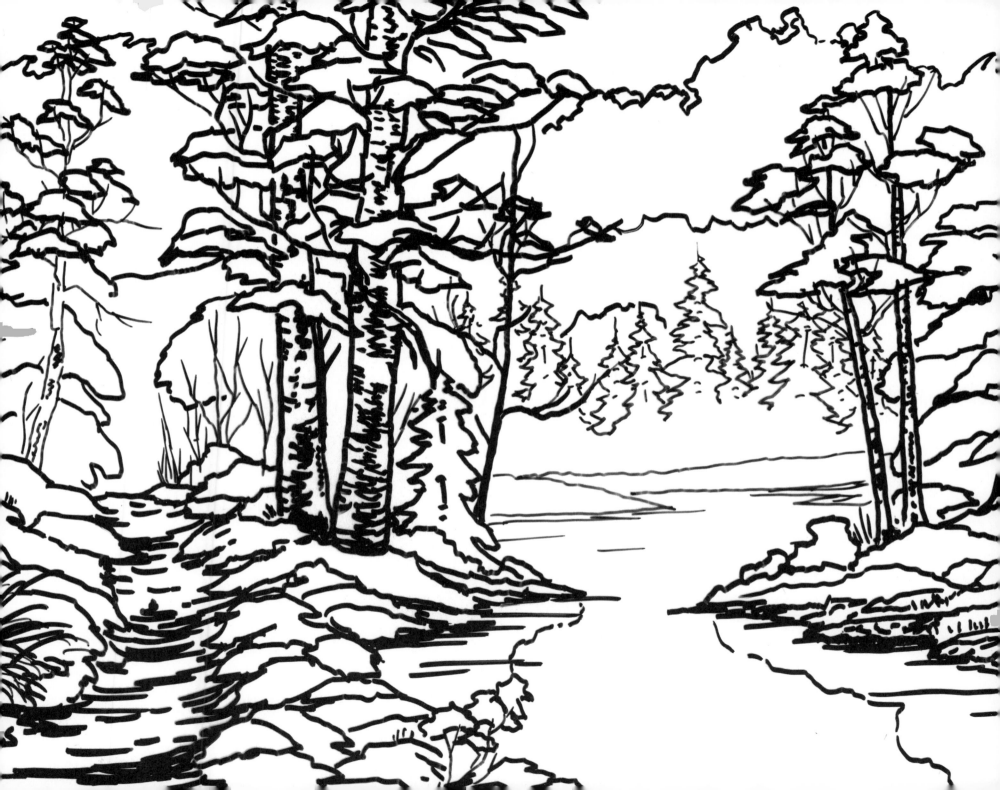

"And now we have a happy little stone that lives out there. And he watches the water fall and he has a good time because he can watch all the creatures."

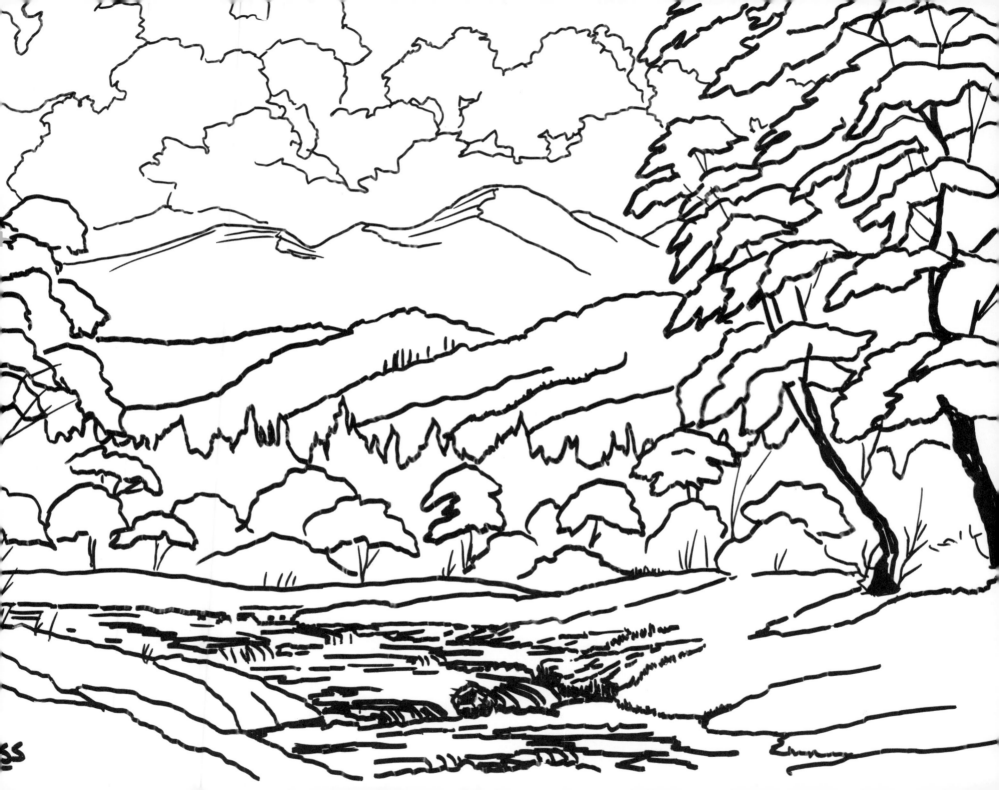

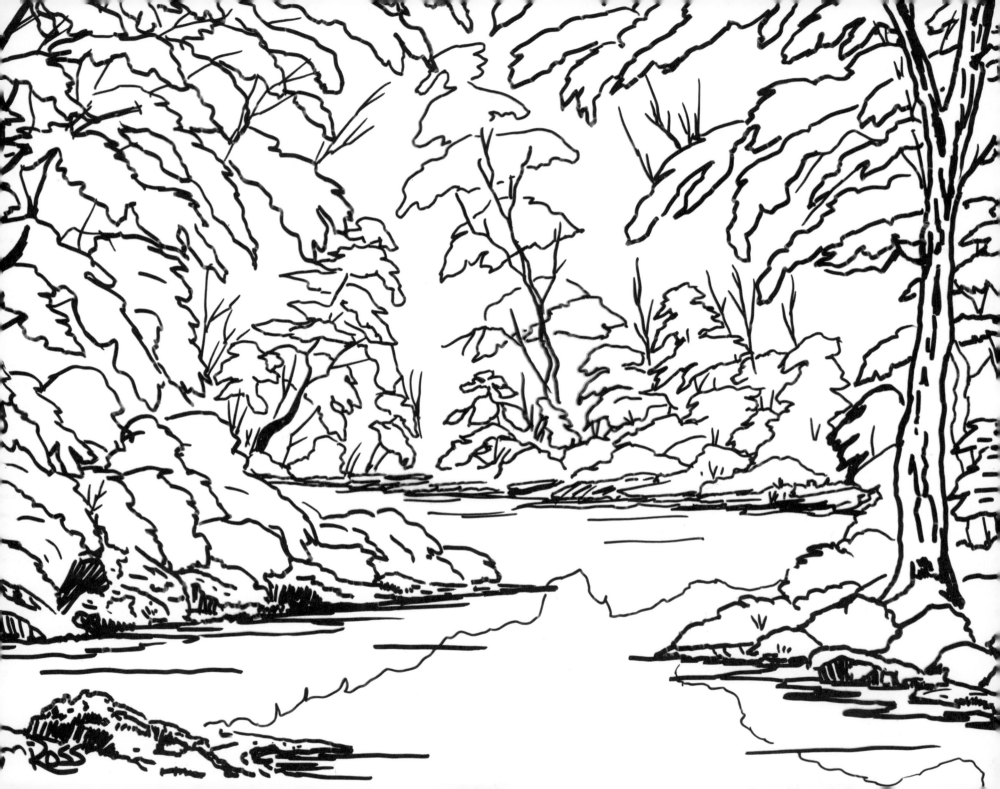

"Every painting is going to be different,
and that's what makes it great."

"Let's make some nice little clouds
that just float around and have fun all day."

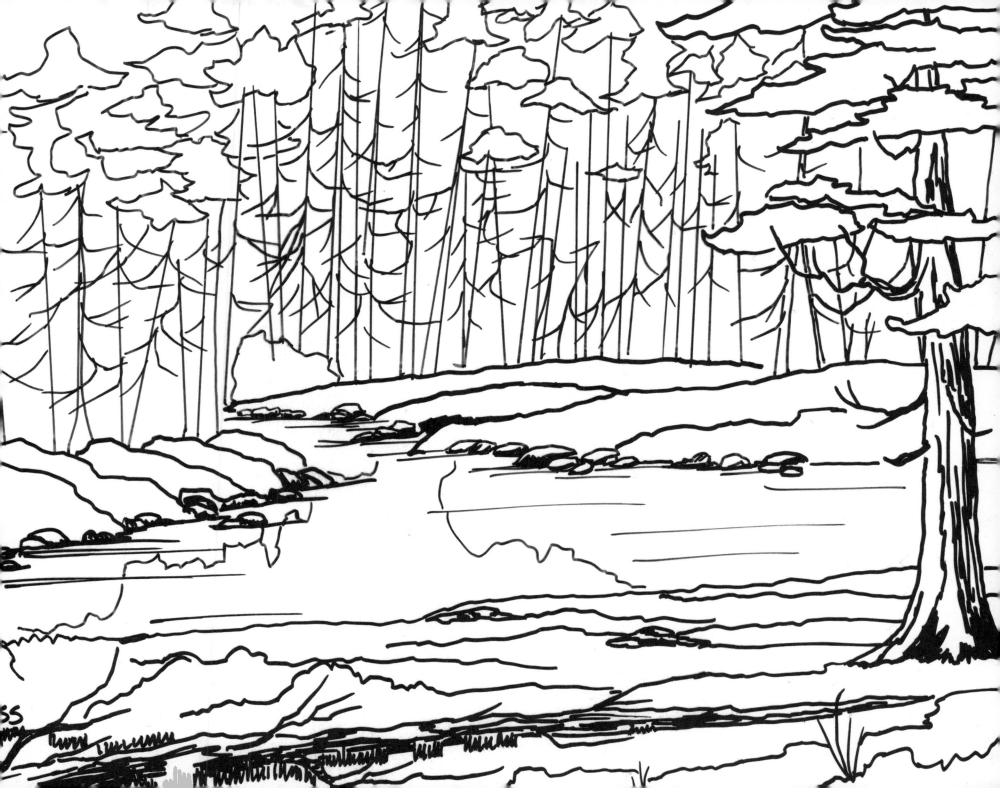

"Painting is as individual as people are."

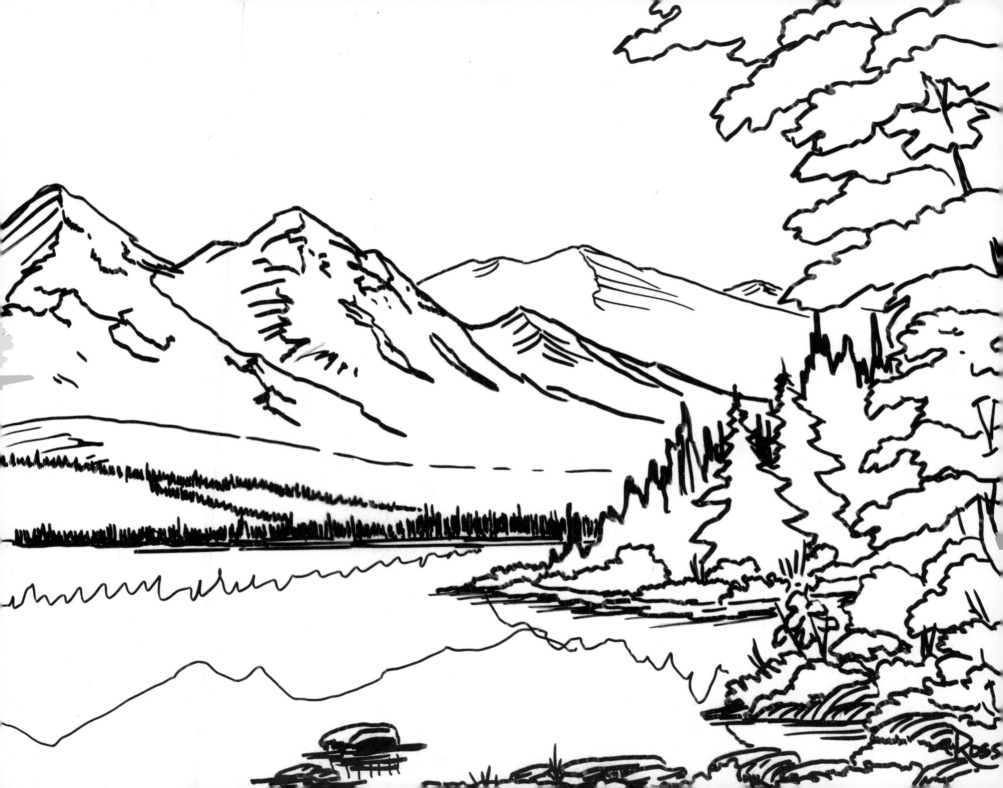

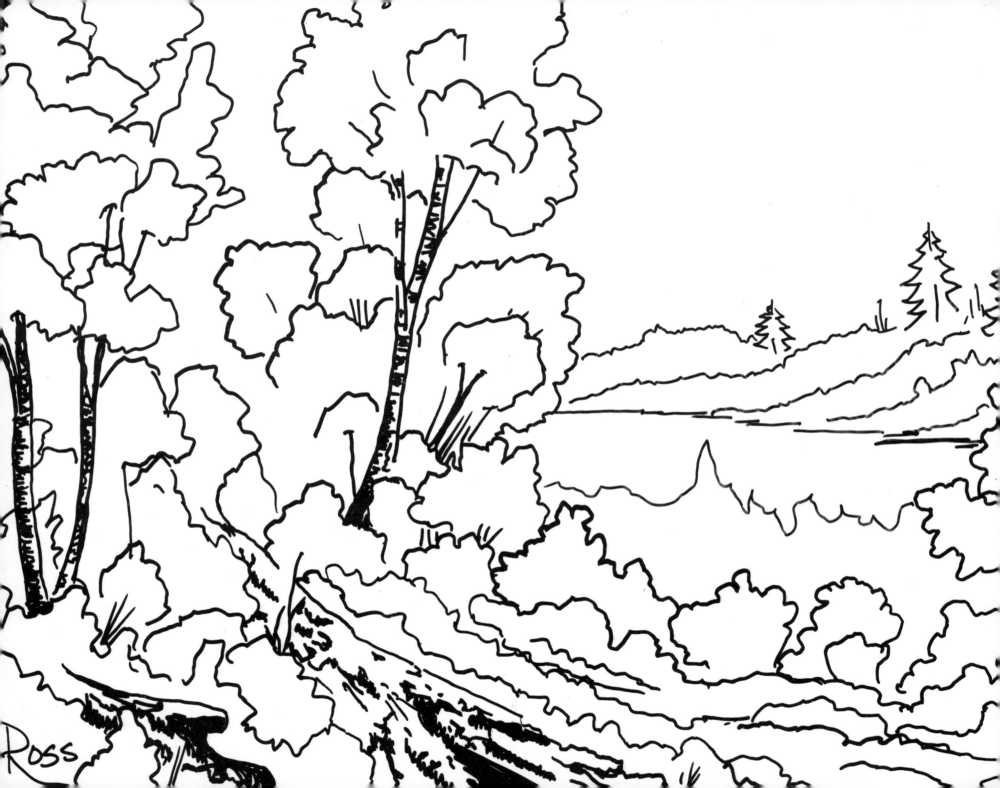

FALL

"You have to have dark in order to
show light, just like in life."

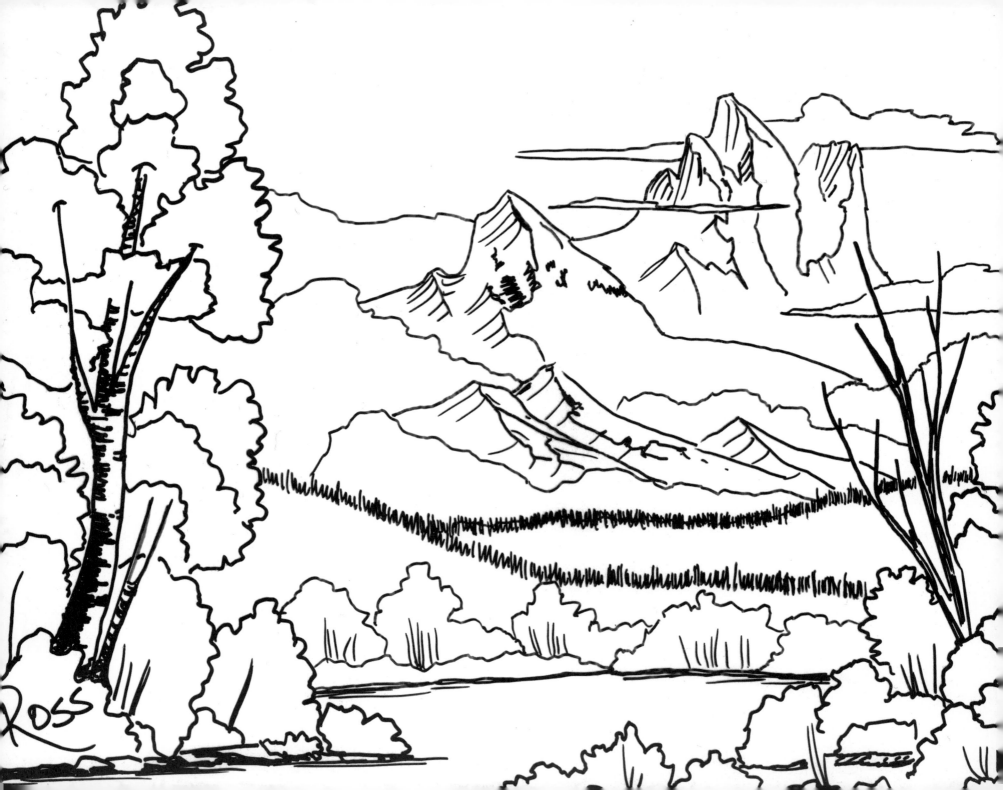

"You have unlimited power here, you can do that. You can do anything on this canvas, anything."

"You know what happens if there're two trees. Pretty soon there're are going to be three and then there're going to be four, and then you're going to have a forest."

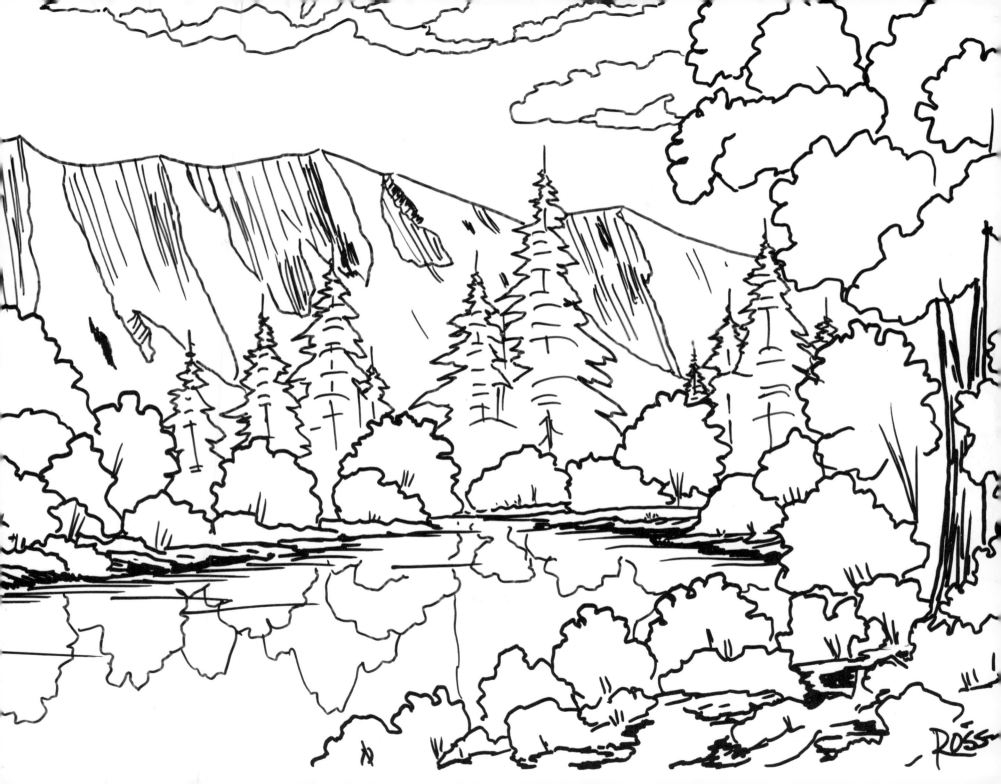

"Just relax, be calm, be peaceful, but let it go."

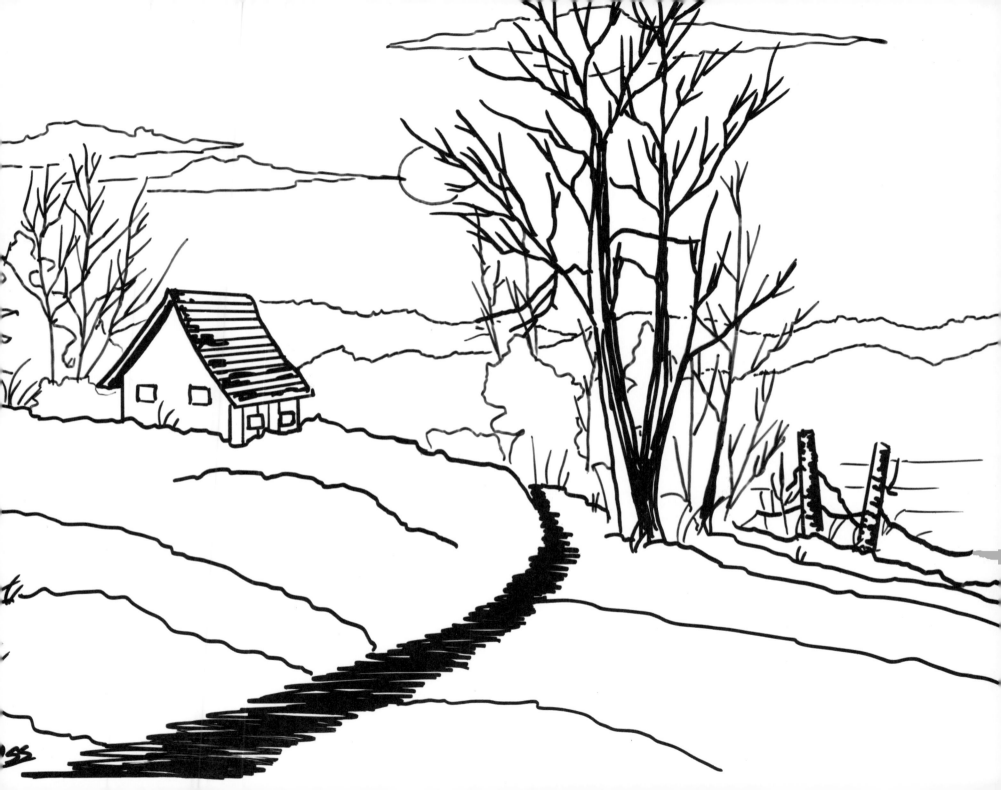

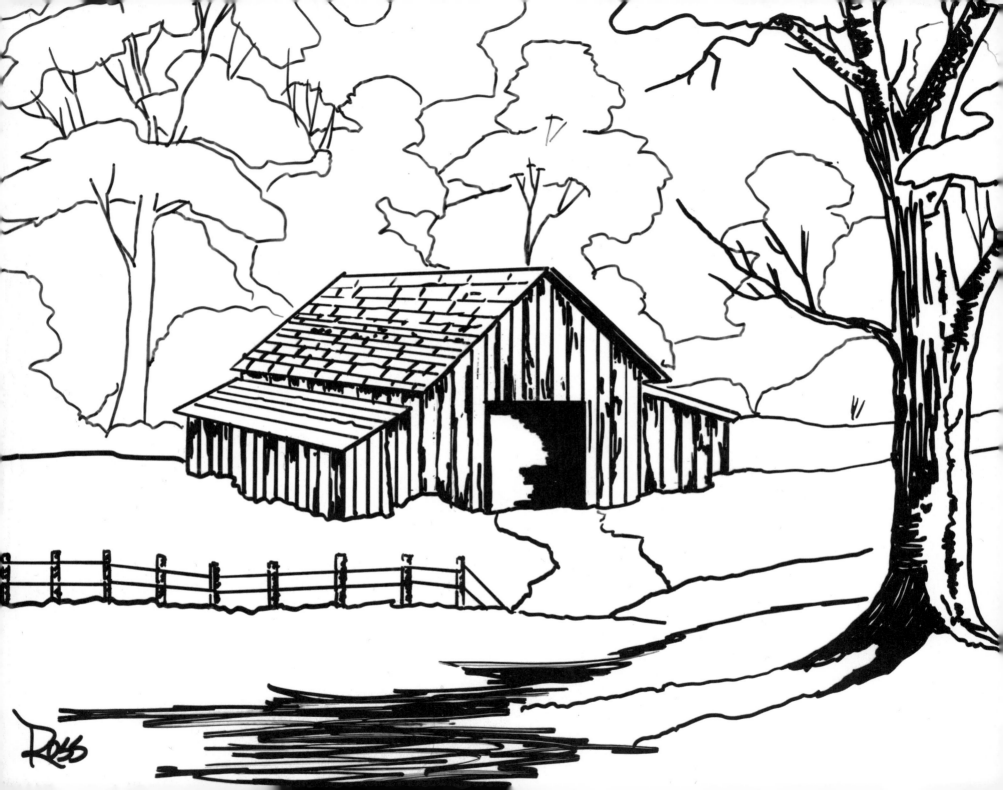

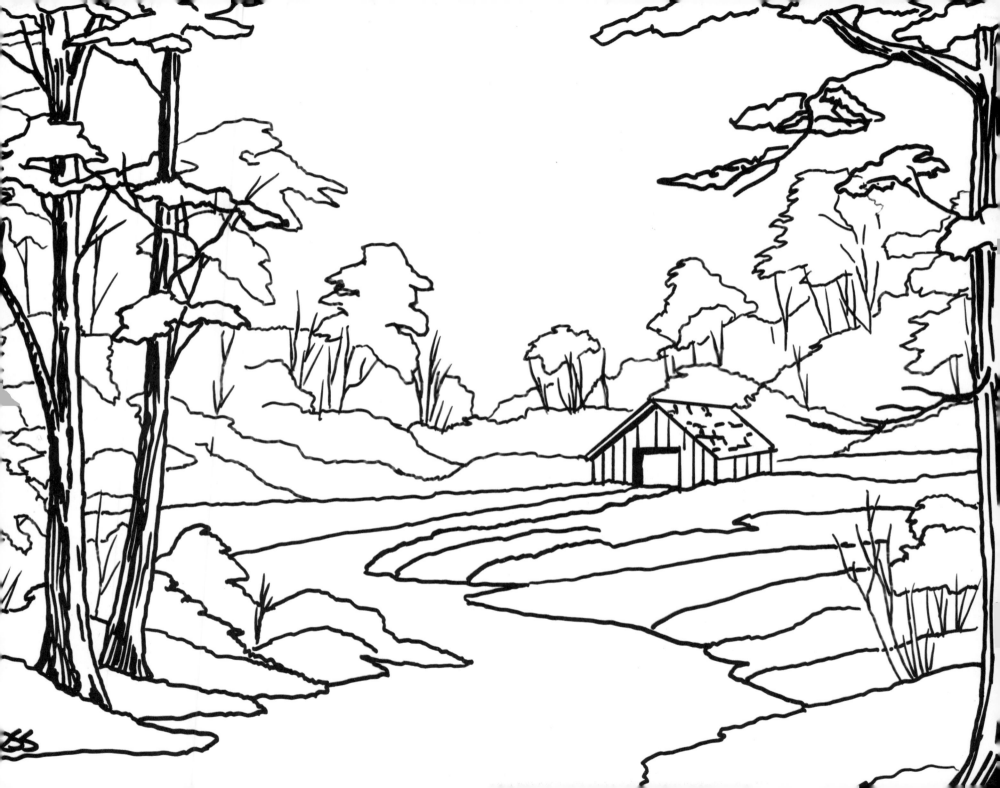

"If painting teaches you nothing else,
it teaches you to look at nature."

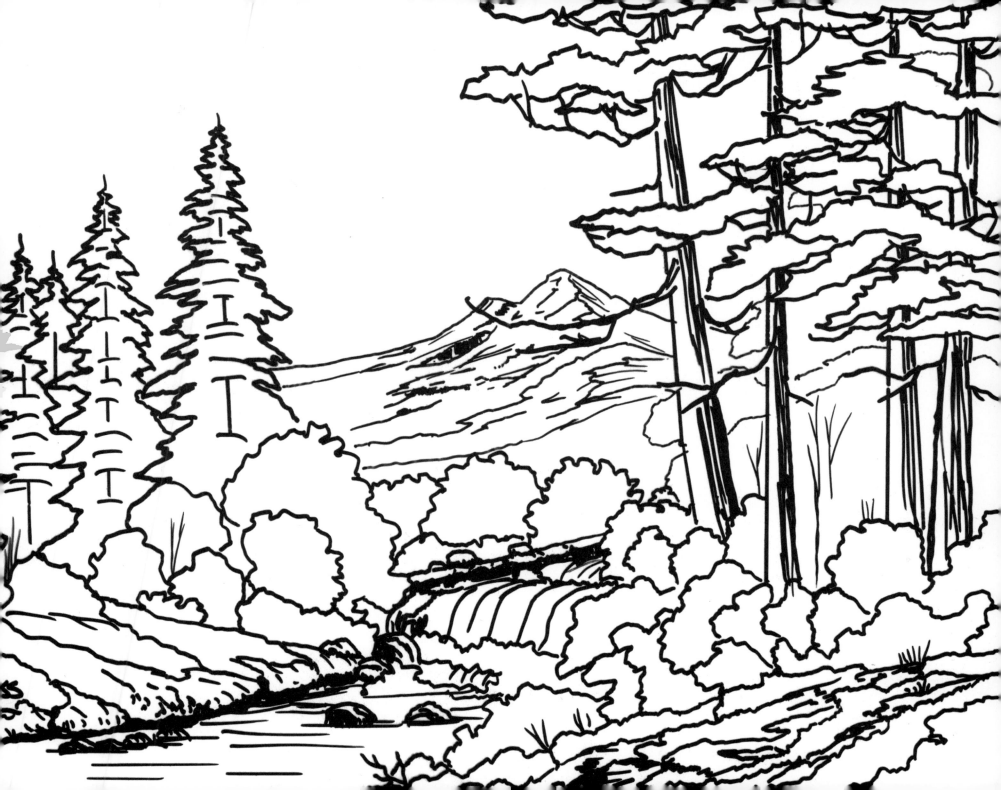

"These things live right in your brush—
all you have to do is shake them out..."

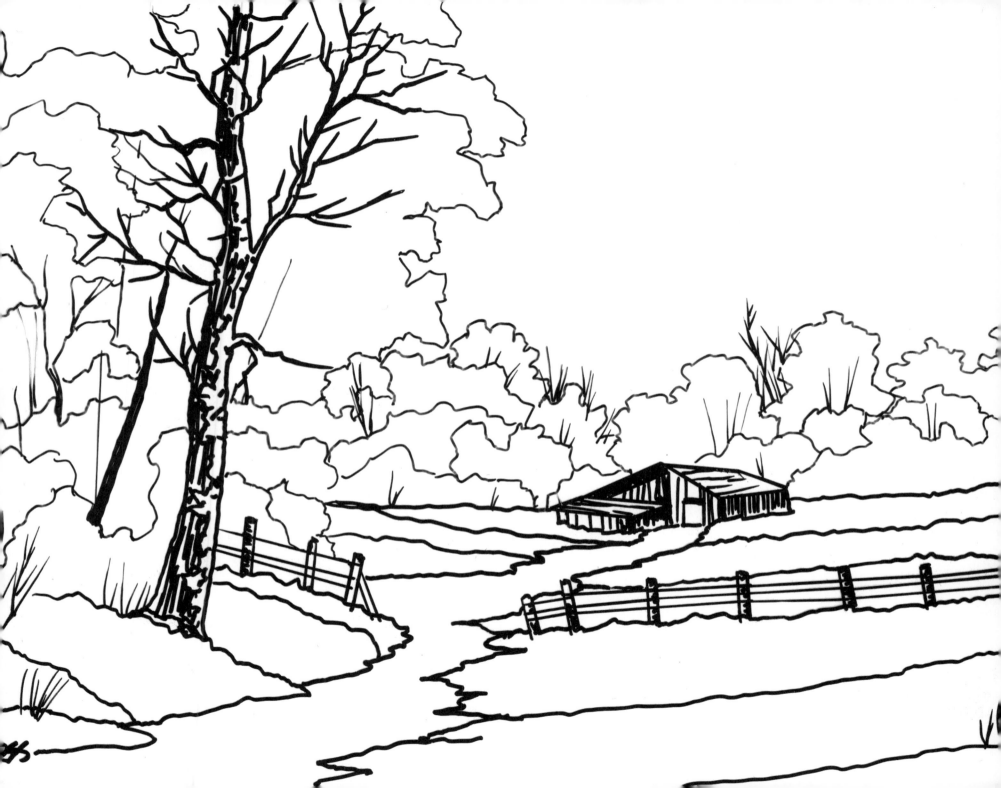

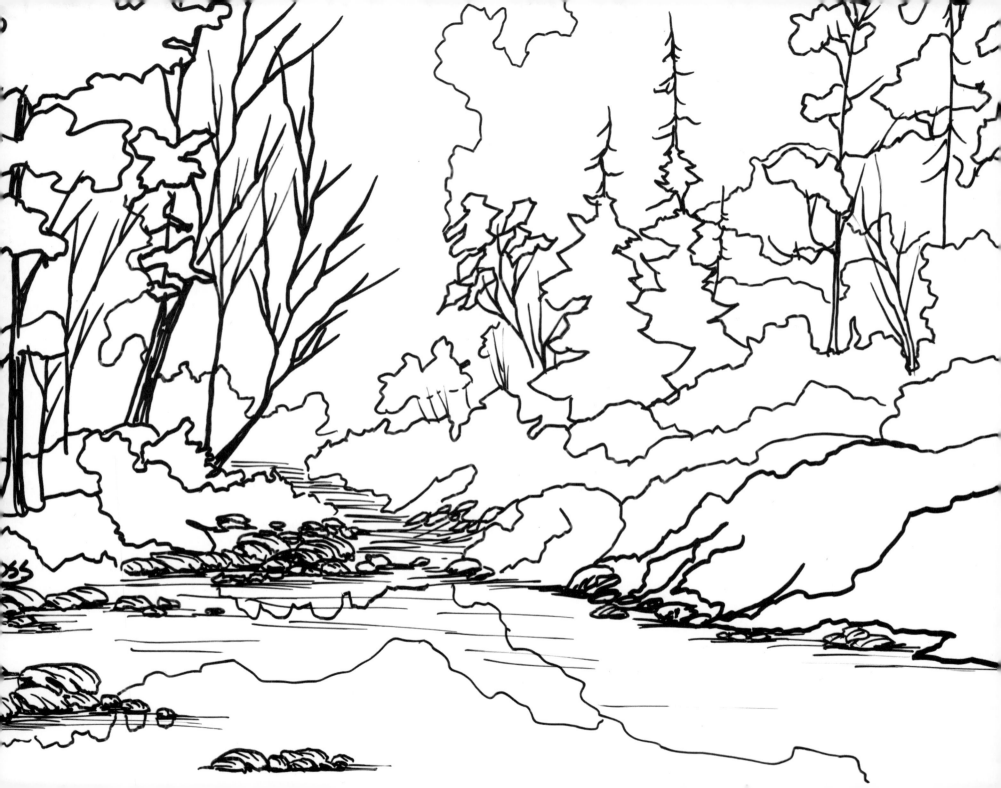

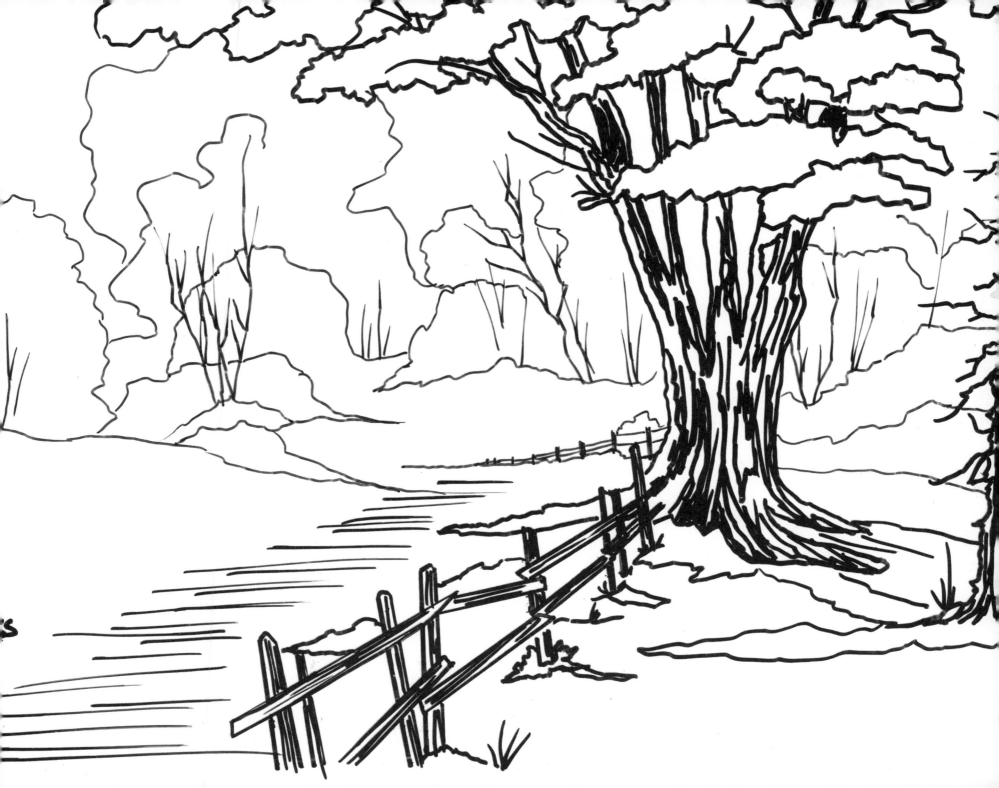

"There's enough unhappy things in the world, painting should be one of those things that brightens your day..."

"Happy painting, and God bless, my friend..."

The Official Bob Ross Coloring Book

First published in the United States of America in 2019 by
UNIVERSE PUBLISHING
A division of Rizzoli International Publications, Inc.
300 Park Avenue South
New York, NY 10010
www.rizzoliusa.com

2020 2021 2022 2023 / 15 14 13 12 11 10

Design by Lynne Yeamans / Lync
Printed in China

ISBN-13: 978-0-7893-3681-1
Library of Congress Control Number: 2018965835